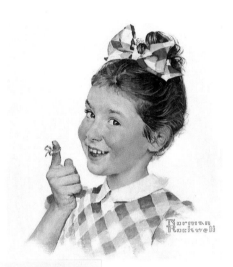

Wisdom With Understanding is Better Than Rubies

Lurine Karow Greenberg
Fine Arts Collection

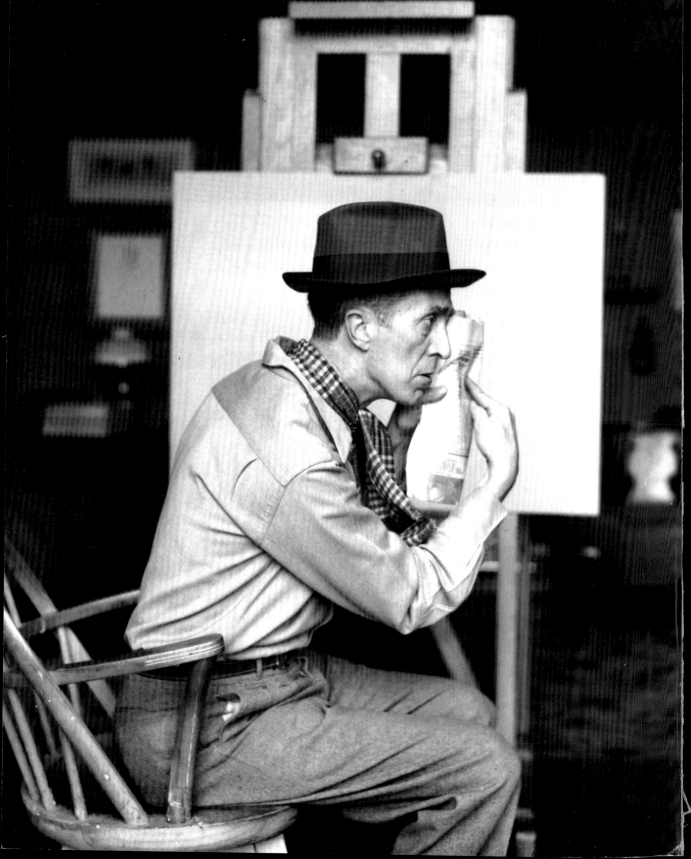

Karal Ann Marling

NORMAN ROCKWELL

1894–1978

America's Most Beloved Painter

TASCHEN

KÖLN LONDON LOS ANGELES MADRID PARIS TOKYO

To stay informed about upcoming TASCHEN titles,
please request our magazine at www.taschen.com
or write to TASCHEN America, 6671 Sunset Boulevard, Suite 1508,
USA–Los Angeles, CA 90028, Fax: +1-323-463.4442.
We will be happy to send you a free copy of our magazine
which is filled with information about all of our books.

© 2005 TASCHEN GmbH
Hohenzollernring 53, D–50672 Köln
www.taschen.com
© 2005 The Norman Rockwell Family Entities
Project management: Petra Lamers-Schütze, Cologne
Consultant: Jim Heiman, Los Angeles
Coordination: Christine Fellhauer, Cologne
Production: Horst Neuzner, Cologne
Layout: Claudia Frey, Cologne

Printed in Germany
ISBN 3-8228-2304-x

Contents

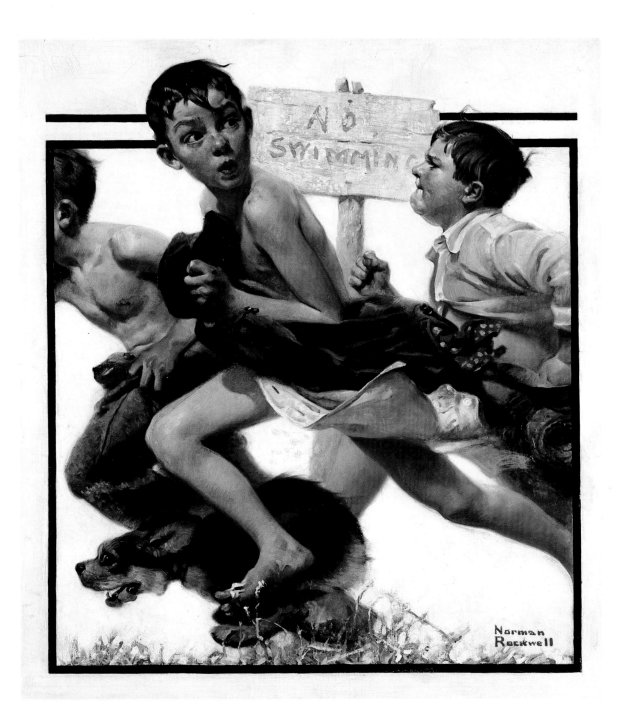

Kids and Cops: An illustrator learns his trade

Norman Rockwell is America's best-loved artist. His works have been reproduced on greeting cards, calendars, figurines, and most recently in a series of ads for the ongoing coverage of the World Trade Center disaster in the *New York Times*. His magazine covers for the *Saturday Evening Post*—over 300 of them in all—have been collected and cherished by its millions of loyal readers, their children, and their grandchildren. And yet, until very recently, his portraits of America and Americans have been overlooked or openly denigrated by critics of the fine arts.

Illustration, they seem to imply, is some lesser branch of image-making, excluded from serious consideration by its own popularity and the commercial venues in which it appears. The irony, then, is that America's best-loved artist was an illustrator who, in a career that spanned some 60 years of the last century, almost never painted a picture that wasn't intended to be an ad, a cover, a calendar, a gloss on a magazine story, or a Christmas card. Indeed, the for-profit context in which Norman Rockwell labored so successfully may make him the most American of all artists in a period that both witnessed and celebrated the primacy of American commercial enterprise.

Norman Rockwell's art-for-hire reached the widest audience of any New World image-maker active since Columbus arrived in 1492. That is the essential paradox of Rockwell's life: he was America's best-loved and most famous artist but, according to the gatekeepers of the institutional world of art, he wasn't an artist at all.

The other charge leveled against Rockwell is falsity, fakery. His America is too neat, too sweet, and entirely too rural and old-fashioned, his detractors say. In a cover for *Literary Digest*, painted in 1920, smiling kids ride to a one-room schoolhouse on horseback (p. 8). The most serious crime in Rockwell-land occurs in an early *Saturday Evening Post* cover (p. 6), when three fresh-faced country boys (and their dog) disobey a sign that forbids swimming in a nearby pond and find themselves pursued by the local sheriff. For the most part, however, Rockwell's sheriffs doze in the sun for want of genuine criminality, as in a typical advertisement for Fisk Tires (p. 11). There are no really bad children in his pictorial world, either: Santa's biggest worry (p. 14) is how to squeeze enough money out of his annual budget to deliver presents to absolutely everybody.

The happiness and simplicity of Rockwell's vision of America may have been conditioned by his own childhood. Born in 1894 in New York City, he pined for

There's a Reason, 1919
Ad for Post Grape Nuts cereal, reproduced in *Literary Digest*, June 28, 1919, p. 24

ILLUSTRATION PAGE 6:
No Swimming, 1921
Painting for *Saturday Evening Post* cover, June 4, 1921
Oil on canvas, 64 x 56.5 cm
Stockbridge, MA, The Norman Rockwell Museum

Everything is in frantic motion toward the left: the boys, the towels, the hastily retrieved clothing, and, most of all, the dog. This helps the viewer to imagine a sheriff in hot pursuit, just off the right edge of the picture.

Off to School, 1920
Literary Digest cover, September 4, 1920
Stockbridge, MA, The Norman Rockbridge
Museum

Although Rockwell is remembered as a painter
of mischief-seeking little boys, many of his best
early works feature girls of undeniable sweetness
and charm. His is not strictly a man's world.

the countryside almost from the beginning. The young Norman was skinny and clumsy at sports. He feared the rough neighborhoods near his family's home on the Upper West Side. Coddled by his mother, Nancy, who boasted of her English heritage and artistic forbears, he also came to resent her imaginary illnesses and spates of religious fervor (during which Norman and his older brother Jarvis found themselves wearing choir robes when they would have preferred play time).

Their father, Waring, who worked in the textile business, often spent his evenings at the dining-room table copying illustrations out of magazines. This was the so-called "Golden Age" of illustration. Its superstars included Charles Dana Gibson and Harrison Fisher, renowned for their pretty, haughty bevy of American girls, homegrown angels with wondrous poufs of shining hair. There was Howard Pyle and his swashbuckling pirates, and N. C. Wyeth, whose Robin Hoods and Revolutionary soldiers seemed to leap right off the page.

Norman drew alongside his father in the circle of lamplight that created a mood of warmth, quiet, privacy, and domestic contentment. He delighted in those nights when the elder Rockwell would lay aside his own pen and read Dickens' novels aloud to the family. As Waring read, Norman drew David Copperfield and Mr. Pickwick and the rest; his strong sense of narrative and his eye for the telling detail were byproducts of those long, nurturing evenings in his father's company.

There were summer vacations, too. Norman loved the freedom of the countryside, the chance to run and play and try out the swimming hole without the anxieties bred of noisy streets and crowds of strangers. His pictorial interest in the joys of being a real, outdoors kind of boy—the subject of much of his early work—began as early as 1904, when the Rockwells summered in Florida, New York.

The family moved as their economic situation dictated. In 1907, they were living in Mamaroneck, New York, a commuter town on Long Island Sound, 25 miles from Manhattan. Bored with school, Norman began riding a succession of trolleys and subways into the city to attend art classes on the weekends. He took classes at the finest schools of the day: the Chase School of Art, under the direction of the flamboyant society painter, William Merritt Chase; the venerable if stodgy National Academy of Design; an idyllic summer course led by Charles Hawthorne in the artists' colony at Provincetown; and finally, the Art Students League on West 57th Street.

At a time when illustrators were still media stars and their pictures America's public art, Rockwell decided to pursue that branch of the artistic profession at the League, under the tutelage of Thomas Fogarty. Fogarty's chief contribution to the young man's future career was his professionalism; he taught his classes the importance of meeting deadlines, honoring commitments, and following the client's wishes. In the classroom, he also used exercises that stressed storytelling in paint and the importance of narrative values. Most important, perhaps, he found real if minor assignments with less popular magazines for his novices. For Norman, his prize pupil, he engineered the position of art editor for *Boys' Life* in 1913. Rockwell's lifelong fascination with happy, healthy children, secure in their safe, friendly villages, began with the *Boys' Life* job.

Now, Norman was in a position to augment his father's earnings. The Rockwell clan promptly moved again, to New Rochelle, New York, where his mother's health propelled the family into life in a succession of boarding houses. As much as Norman resented the false camaraderie and loss of privacy, he relished life

"I guess I have a bad case of the American nostalgia for the clean simple country life as opposed to the complicated world of the city."
NORMAN ROCKWELL

Boy with Baby Carriage, 1916
Painting for *Saturday Evening Post* cover, May 20, 1916
Oil on canvas, 53 x 47 cm
Stockbridge, MA, The Norman Rockwell Museum

The first cover Rockwell did for the most prominent picture magazine of his era,
this image set the tone for the images America came to expect from its most
beloved artist: cute kids, mild humor, and a judicious use of eye-catching color.

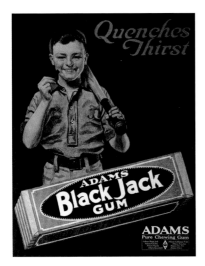

Quenches Thirst, 1920
Ad for Adams Black Jack gum, reproduced in
Saturday Evening Post, March 20, 1920, p. 80

in the town, which had become a kind of illustrators' colony, convenient to Manhattan and the offices of the big ad agencies and publishers. The fabled Leyendecker brothers, Frank and Joe, whose work for the *Saturday Evening Post* and elite consumer products had earned them a fancy mansion, were the leading lights of artistic New Rochelle. But there were others as well, including Coles Phillips, whose slightly naughty "fade-away" girls in lingerie ads had made him a household name.

Eventually the youngest member of the fraternity settled into a big barn of a studio—a galvanized iron barn, in fact, in which Frederick Remington, illustrator of the vanishing American West, had once conjured up thrilling scenes of Indians and cowboys. Norman shared the studio with Clyde Forsythe, a popular cartoonist and Rockwell's first and most sympathetic critic. Forsythe advised his friend to do what he did best—kids—and to give up on the sophisticated society-girl stuff that the best magazines so often used. "C-R-U-D," said Clyde, as Norman struggled to paint a soigné debutante being kissed by one of Joe Leyendecker's Arrow Collar men. "You can't do a beautiful seductive woman. . . . Give it up."

Under Forsythe's prodding, Norman went back to his cast of boy models from the neighborhood and headed for Philadelphia and the offices of the *Saturday Evening Post* with a bundle of brand new cover ideas. The *Post* was, and would remain through the 1950s, the most widely-circulated periodical in the nation, respected as much for the attractiveness of its covers and illustrations as for its articles. A nod of approval from editor George Horace Lorimer could propel a newcomer into the top ranks of Norman's chosen profession. And so, in March of 1916, Norman Rockwell's career as a major figure in the world of illustration really began when Lorimer bought two cover pictures outright—and approved three sketches for future use.

The pictorial cover was crucial to the success of a magazine. It had to make itself visible and comprehensible at a distance, so the casual passerby would want to pluck that issue off the rack at the newsstand. It had to identify the *Post* and carry with it some slight hint of the character of the journal. While covers rarely pictured items discussed on the inside pages (except for holiday numbers), the design had to convey something of the mood and tenor of the contents. In a sense, it also needed to mirror the taste and status of the potential reader, who could see him- or herself in that image. Covers were a tricky business, and one crucial to the success of the *Post*.

Rockwell's very first *Post* cover appeared on the issue dated May 20, 1916 (p. 9). It shows a mortified little boy, dressed in his Sunday best, pushing a baby carriage past two erstwhile pals in baseball uniforms who mock him mercilessly for his unmanly task and his "swell" duds. In the teens of the century, *Post* covers were two-color affairs, with a carroty red set off against grayish brown on a white background. Norman used the white paper to advantage in the stiff collar and cuffs of the junior gentleman, and the milk in the nursing bottle stuck in the pocket of his suitcoat. Similarly, the spots of red on his boutonniere, on the uniforms of his tormenters, and on the baby's bootie create a circular rhythm that frames the key incident and binds the composition into a coherent whole. To be seen with a perky red flower and a bottle of formula in front of his own friends makes the kid's humiliation all the worse.

One boy posed for all three youngsters. The clear similarities help to make the babysitter's predicament—his sudden isolation from his peers—more obvious, although Rockwell used hats, haircuts, and facial expressions to disguise the

"At the beginning of the modeling sessions I'd set a stack of nickels on a table beside my easel. Every 25 minutes . . . I'd transfer five of the nickels to the other side of the table, saying, 'Now that's your pile.' The kids liked that."
NORMAN ROCKWELL

shortage of sitters. The youngster was Billy Paine, whom Rockwell considered one of his best child models, "a swell kid, a regular rapscallion." To keep Billy and the others in the proper poses, he would put their wages on a nearby table in the form of a stack of shiny coins. At every rest period, a few nickels would move from Norman's pile to the model's, until the job was done.

Despite the homey stories about Rockwell and his models that he would later tell about himself, there is real artistry in these seemingly simple tableaux. *No Swimming* (p. 6) is a case in point. A complex mixture of naughtiness and innocence, the picture is also a study of motion—a cinematic sense of movement frozen in mid-step. The two boys to the right and left sides of the composition are cut off by the edges of the frame, as if by the lens of the camera. In the 1920s (and for years thereafter), illustrators routinely denied using photos as aids in their work. When Rockwell's older comrades were expecting visitors, they first purged their studios of all evidence of cameras and other photographic equipment. But it was an open secret that the camera was in common use, not only

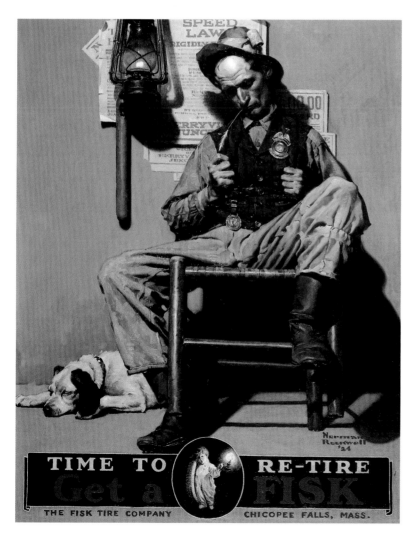

Time to Re-Tire: Sleeping Sheriff, 1924
Ad for Fisk Tire Company
Oil on canvas, 73.5 x 57 cm
Private collection

The sleepy toddler with his automobile tire and candle, along with the slogan "Time to Re-Tire," had been the company trademark for many years when the Massachusetts firm called upon Rockwell to update its image. His earliest Fisk ads—for bicycle tires—appeared in *American Boy* magazine. By the mid-20s, Rockwell's repertory had enlarged, and Fisk commissioned another series of adult-oriented ads.

as a practical means of capturing a difficult pose—Rockwell used blocks and struts to help models hold difficult poses like that of skinny Franklin Lischke, the Norman look-alike in the center of the picture—but also to add interest to otherwise static compositions, with fresh angles of vision.

In this work, too, the sense of rapid, fleeting motion is enhanced by the figure of the dog, whose frantic determination to escape the long arm of the law sets the pace for the actions of the boys. While telling a simple, humorous anecdote by the most expeditious means, however, Rockwell also displays an extraordinary dexterity at traditional modes of painting in the subtle brushwork and range of color most notable in the bottom half of the image. Franklin's right leg is a text-book example of using blues and reds to delineate the muscular structure of the body with a tenderness and delicacy altogether suited to the limb of a child.

Rockwell's art was so deeply engaged with the world of ordinary Americans that real, live models were—at least in his own eyes—crucial to his success. In addition to the children of New Rochelle, he developed a cadre of mature male

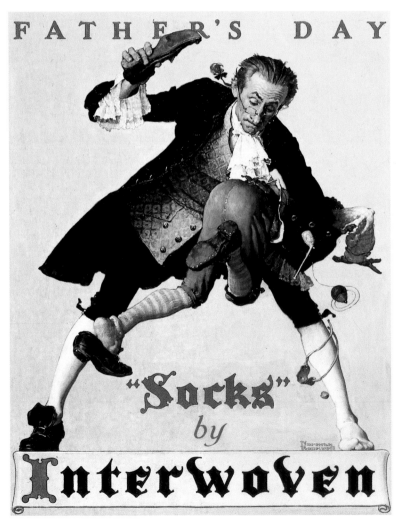

ILLUSTRATION PAGE 12:
Father's Day, c. 1930
Ad for Interwoven Socks
Oil on canvas, 84 x 66 cm
Private collection

Holidays were also a bonanza for merchants. As this example shows, there was often little difference between the covers and the seasonal ads inside magazines like the *Post*. The use of the same artists illustrating the same motifs helped to confuse advertising with editorial content.

ILLUSTRATION PAGE 13:
Schoolmaster Flogging Tom Sawyer, 1936
Illustration for Heritage Press centennial edition of Mark Twain's *Tom Sawyer*, p. 92
Oil on canvas, 63.5 x 51 cm
Hannibal, MO, Mark Twain Museum

The subject matter was perfect for Rockwell and he was enthusiastic about the chance to illustrate a masterpiece of American letters. He traveled to Hannibal, Missouri, visited caves along the Mississippi, and borrowed clothes for use as costumes. The trip and the Midwestern theme gave him a certain affinity with the popular Regionalist painters of the day, including Thomas Hart Benton, who hailed from Missouri.

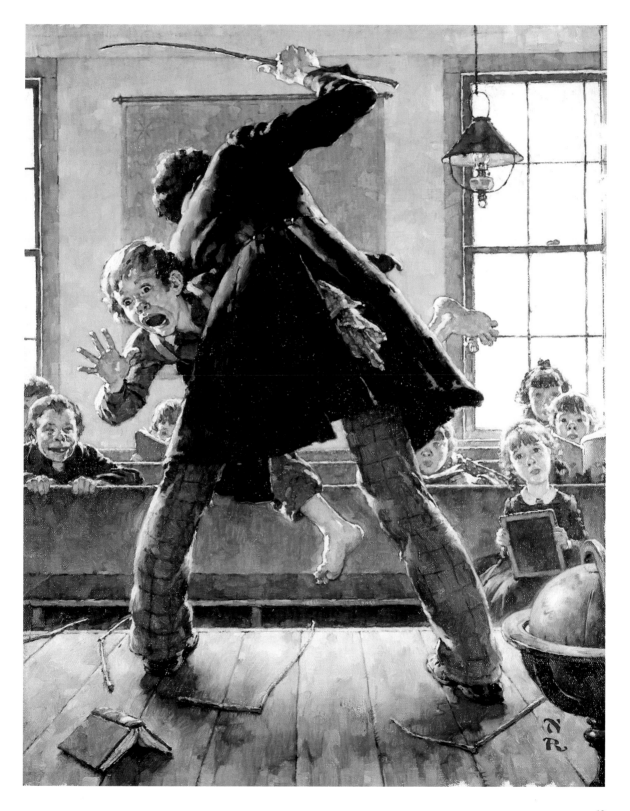

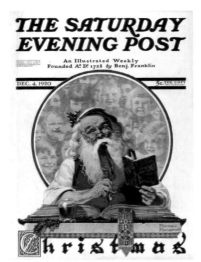

THE SATURDAY EVENING POST

An Illustrated Weekly
Founded A.D. 1728 by Benj. Franklin

DEC. 4, 1920 5c. THE COPY

Christmas

Santa and His Expense Book, 1920
Saturday Evening Post cover, December 4, 1920
Stockbridge, MA, The Norman Rockwell
Museum

Festive holiday covers guaranteed big newsstand
sales; illustrators competed for the honor of
doing each year's cupids and Easter bunnies.
Santa became a Rockwell specialty, here com-
bined with his characteristic children, as imag-
ined by the old man in the vignette behind his
head.

models, some of them professionals who had posed for classes at the League, and
others local tradesmen coaxed into pretending to be schoolmasters, lawmen, or
colonial worthies.

Among his favorites was the thin, long-faced Dave Campion, proprietor of
a nearby newsstand: Rockwell needed to exaggerate his angular frame only
slightly to lend a touch of humor to ads for Interwoven Socks (p. 12) and a book
illustration showing Tom Sawyer being caned by a lanky schoolmaster (p. 13).
Occasionally, his clients objected to seeing the same cast of characters over and
over again in the guise of Santas, Pilgrims (p. 15), or members of a *Barbershop
Quartet* (p. 17). Rockwell admitted that he had paid one of his favorite old gentle-
men $10 to shave off his glorious mustache so he could be used more often (once,
as three old ladies!).

With works like these appearing regularly in both ads and cover pictures,
Norman Rockwell had reached the top of his profession in record time. His
career would soon make him a true celebrity, whose angular frame and trade-
mark pipe were at least as famous as any of the characters he conjured up for
the delight of his public. He had become a part of the child-centered world of
lively boys and cute little girls (p. 7), of funny-looking and often ineffectual
elders that conjured up sweeter, simpler times. As the Roaring Twenties roared
on, Rockwell's America looked back to the simplicities of rural life, to kids play-
ing baseball (p. 10), to school holidays, and a make-believe version of American
history in which schoolmasters and addled Pilgrims looked a lot like the grumpy
fellow who sold papers on the street corner.

ILLUSTRATION PAGE 15:
Thanksgiving—Ye Glutton, 1923
Painting for *Life* cover, November 22, 1923
Oil on canvas, 79 x 59 cm
Stockbridge, MA, The Norman Rockwell
Museum

During the 1920s, the nation was in the grip of
a mania for things "colonial." Pilgrims, saltbox
houses, and antiques of all sorts helped to miti-
gate the perceived ills of the modern era of
changing manners and mores. Here, the 17th
century worthy makes a 1923 reference to
overeating at the traditional turkey dinner.

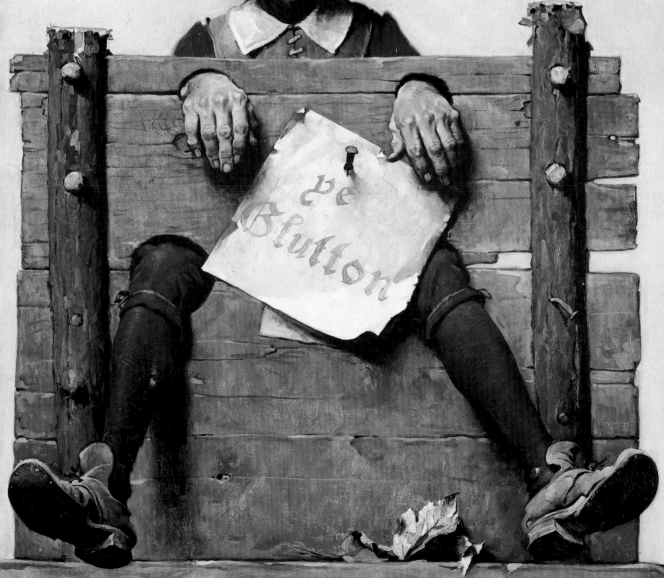

Fame and Fortune

During the 1910s and 20s, Norman Rockwell came into his own. He married a schoolteacher, Irene O'Connor, who lived in the same New Rochelle boarding house occupied by the peripatetic Rockwell family. Discharged from the Navy after brief, uneventful service in World War I, he cultivated the important New York art directors, resumed his relationship with Lorimer at the *Post*, and began to make real money. Irene relished the good life: parties, social prestige, the country club set. Norman was not immune to the rewards of fame, either. But they came at a cost.

The big money of the era was in advertising art. Foodstuffs had been one of the first consumer products to be branded, so that the housewife could readily find Post cereals on the grocer's shelf and receive precisely the same item of the same quality every time. In the 1920s, a new, modern wave of edibles hit the mass market, with a corresponding demand for artwork to sell chewing gum, soft drinks, and candy (p. 24). Ad work was lucrative but demanding. Agencies often required artists to sign contracts obligating them to complete a specified number of pictures per year. Rockwell fought clear of most such obligations because of the pressure to produce on a timetable. How could any artist retain his sanity while dreaming up ever more novel ways to make gum appealing, month after weary month? "Security is very nice," he said, "but not if you have to kill yourself or your work to get it."

The proliferation of holidays during the period made the job somewhat easier: Santas for Christmas, various colonial figures for Washington's Birthday, sweethearts for Valentine's Day. The swelling list of festive dates included many occasions for gift-giving and the makers of branded candy and other confectionary goods were quick to colonize the market for inexpensive presents. Big business actively encouraged the recognition of profit-making holidays and, in the process, gave illustrators a ready supply of seasonal imagery which also found its way onto magazine covers. Thus, in the 1920s and 30s, cover art and the full-color ads inside lent a new consistency to the iconography of the magazine. Rockwell soon dethroned J. C. Leyendecker as the master of the *Post's* holiday covers. He also helped to blur the line between advertising and other kinds of illustration.

The Dave Campion series provides a good example of this deliberate fuzziness. In April, 1937, he was the principal subject of a *Post* cover called *The Ticket*

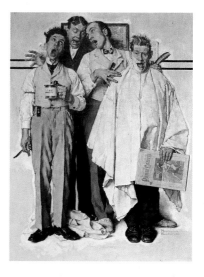

Barbershop Quartet, 1936
Painting for *Saturday Evening Post* cover,
September 26, 1936
Oil on canvas, 91.5 x 69 cm
Private collection

Walt Disney, an American icon in his own right and a friend of Rockwell's, liked this cover so much that he once proposed to build a robotic version of the painting (and its missing setting) to be activated by putting a coin in a slot.

ILLUSTRATION PAGE 16:
Gary Cooper as "The Texan," 1930
Painting for *Saturday Evening Post* cover,
May 24, 1930
Oil on canvas, 89 x 66 cm
Private collection

Seller (p. 19). The story is simple. The man who sells the tickets to wondrous beauty spots around the world is trapped like a tired circus lion within his own cage. During the Depression era, this ironic comment was not wasted on a readership locked in place by economic disaster, an audience forced to conjure up the Orient or the Eiffel Tower from the pictures in magazines. But the same figure is one of Rockwell's most memorable Interwoven Sock men, too.

Ads for ready-to-wear clothing dominated newspapers and magazines after World War I. As opposed to home-tailored or bespoke clothes, the new garments were cheap and easy to come by. Rapid changes in fads and fashions were in the best interests of the manufacturers, of course, but they also helped to accelerate the pace of American life, as it was perceived by the modern consumer. Inexpensive, disposable items of haberdashery, like socks and hosiery and garters, soon rivaled candy and fountain pens as easy gift choices.

At first glance, Rockwell's Interwoven man seems to run counter to the trend toward modernity and change. He is no longer young and often appears in historical costume (p. 12), in keeping with the old-style script of the company trademark. Even when he is a man of the present, he is an uncommon sort of fellow—a valet, for instance, inspecting the young master's sartorial choices with mingled horror and satisfaction (in the case of the sock!). But whether historical or modern (p. 18 bottom), the Interwoven man is first and foremost a Rockwell man, lanky, legs akimbo, big-footed, and benign. The man on the covers and the man in the ads are the same fellow, in the same tone, by the same artist. It's a Rockwell! So it must be a good, dependable sock! Or a trustworthy company (p. 25)! Or a tasty stick of gum (p. 24)!

The Ticket Seller, 1937
Charcoal layout study for *Saturday Evening Post* cover, April 24, 1937
Support and dimensions unknown

Overt references to the economic Depression of the 1930s were rare in Rockwell's cheerful magazine world, but this unhappy figure trapped in his cage may be an oblique nod to the difficulties of the era. In publishing the charcoal, the artist emphasized the need for precise, finished studies before completing a painted version. The study is all but identical to the cover.

ILLUSTRATION PAGE 19:
The Ticket Seller, 1937
Saturday Evening Post cover, April 24, 1937
Stockbridge, MA, The Norman Rockwell Museum

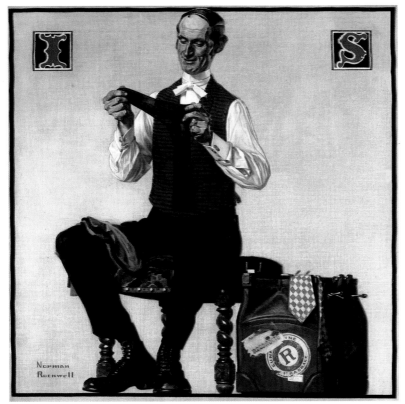

Man Inspecting Socks, 1924
Ad for Interwoven Socks, reproduced in *Saturday Evening Post*, August 9, 1924, p. 105

A New Rochelle neighbor whom Rockwell often used as a model, his appearance in an ad as a valet thoughtfully examining a sock further confuses the difference between advertisements, covers, and in-the-book illustrations.

THE SATURDAY EVENING POST

Volume 209, Number 43

April 24, 1937

5c.

For in

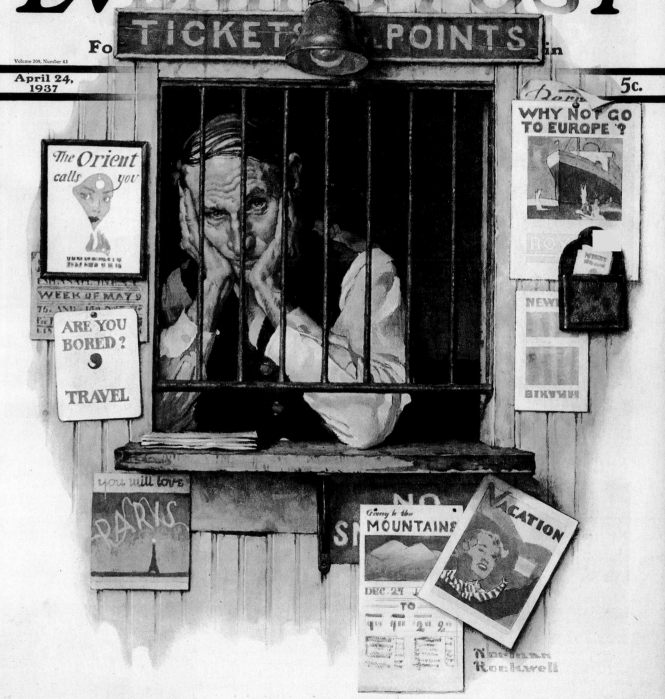

THE $47,000,000,000 BLIGHT—By SENATOR VANDENBERG

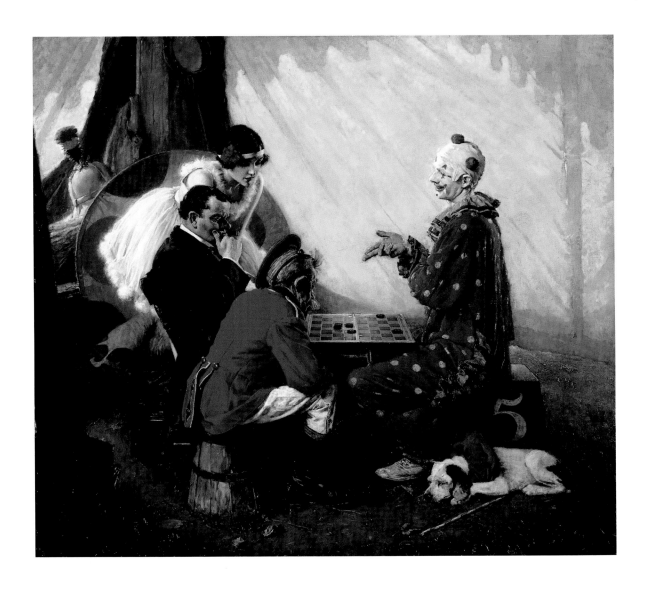

Checkers, 1928
Illustration for *Ladies' Home Journal*, July, 1929, p. 11
Oil on canvas, 89 x 99 cm
Stockbridge, MA, The Norman Rockwell Museum

Pictures that accompanied magazine fiction were fundamentally different from
cover illustrations. They were meant to be savored slowly, in relationship to the text.
Here the painterly application of color, the gestures, and the subtle movement of
light have little in common with the simplified covers of the 1920s.

Because of the success of his magazine covers, it is easy to forget that Norman
Rockwell was responsible for a great deal of inside-the-book illustration, too,
created to complement feature articles and works of fiction. For a cover, Rock-
well essentially made up his own little story and illustrated it. That was also the
case with several of his pieces for the pages of the *Saturday Evening Post* in the
1930s. But he was capable of conventional literary illustration of great dramatic
force. *Love Ouanga* (p. 21), which accompanied a short story in *American Maga-
zine*, enhanced the melodramatic flavor of a tale of racial discrimination in both
black and white communities. Rockwell was an avid collector of colonial era
costumes and artifacts; his *The New Tavern Sign* (pp. 22–23) of 1936 captured
the spirit of the fashionable Colonial Revival then sweeping the country, as the
young artist in his quaint tricorn hat discards a tavern sign featuring a portrait
of the King in favor of a likeness of George Washington. His neighbors look on
in curious admiration, much as Norman's huge national audience now awaited
each new "Rockwell" and shared their opinions of it in the "Letters to the Editor"
column of the *Post*.

By the mid-1930s, Rockwell was the most famous illustrator in America, a
figure whose success prolonged the life of the "Golden Age" of commercial pic-
ture-making well into the 20th century. The economic Depression of the period
hardly touched Rockwell; its effects were curiously absent from his work, for the
most part, too, as if Norman consciously aimed to distract and reassure his vast
following. But the decade was not a placid one for Rockwell, despite his wealth
and reputation. His loveless and often strained marriage to Irene ended in
divorce in 1930. His old life as a man about town—a golfer, a horseman, a bon
vivant—seemed stale and false.

On a therapeutic trip to California, where Rockwell hobnobbed happily with
Hollywood stars, he met and married Mary Barstow, another young school-
teacher. The couple moved into Norman's lavish Colonial Revival home in New
Rochelle (the house and studio had been featured in *Good Housekeeping* in 1929
as the ideal artist's retreat). There Norman and Mary began a family. By 1936,
the Rockwells had three sons. During the unsettled 20s and 30s, Norman also
managed to establish several new themes in his work, preoccupations that would
reappear in a variety of guises for the next 40 years.

One of these was the practice of showing the internal thoughts and desires of
his sitters through visions surrounding their heads. *The Land of Enchantment*
(pp. 26–27), a mural-size canvas developed for a double-page picture inside the

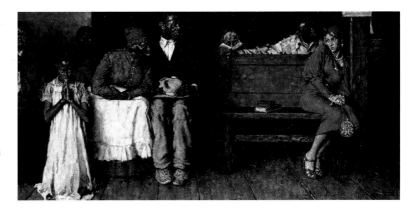

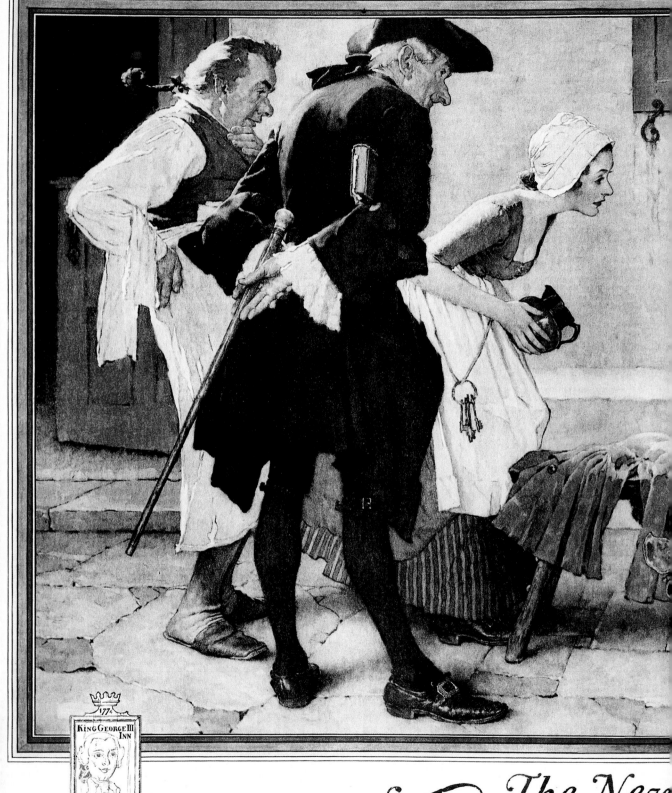

King George III Inn
·1774·

Travelers Rest

The New

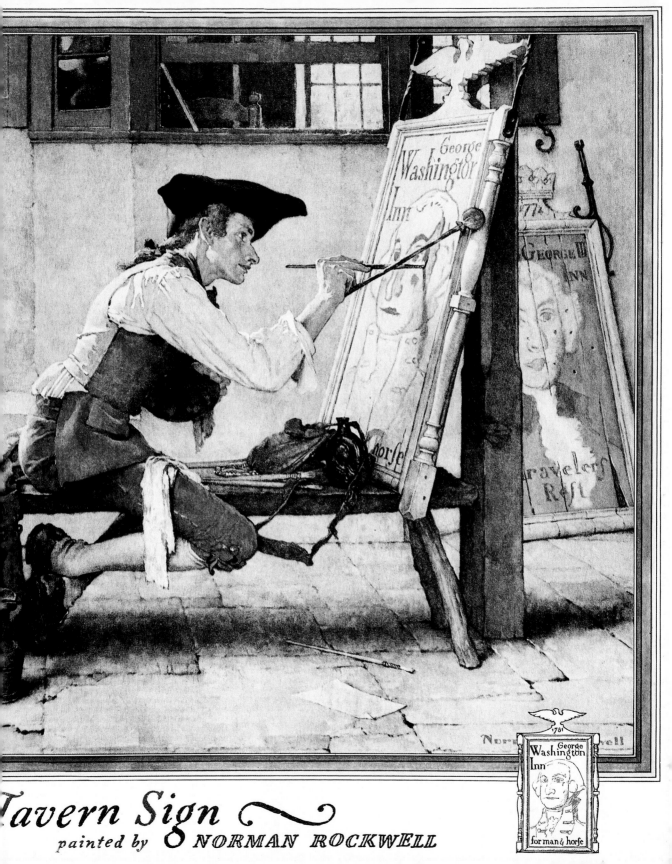

Tavern Sign
painted by NORMAN ROCKWELL

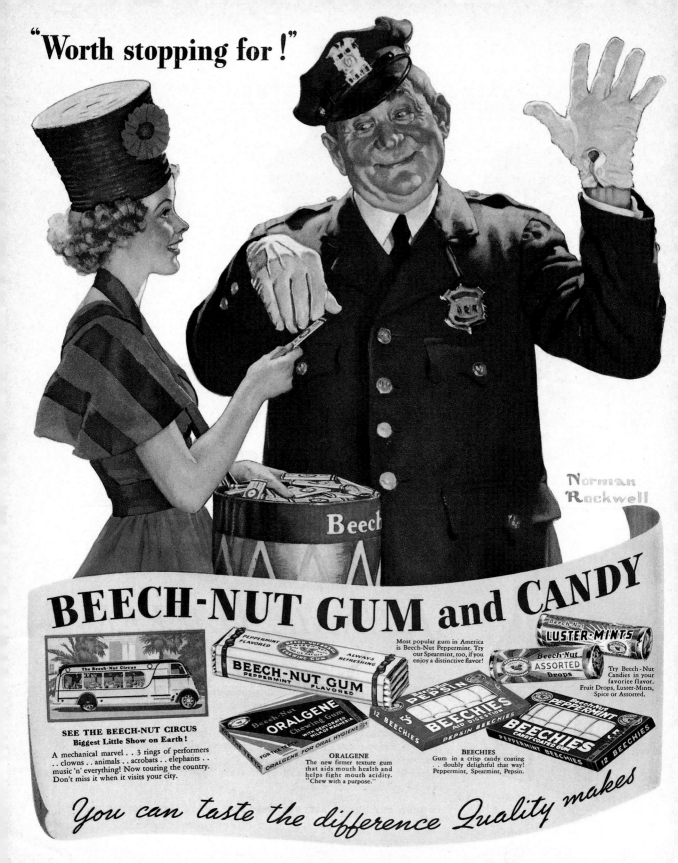

Post, was a tribute to Rockwell's popularity. There was no pressing reason for such a picture to appear at this scale, except as a kind of Christmas offering to the artist's fans. Nor did it accompany an article. Instead, a verse by Lord Byron, underneath the picture, spoke of the "golden dreams" of childhood. Here, Rockwell in fact honors his great predecessors, as the tales in the children's books come to life behind them, in the form of alarming pirates, stealthy Indians, and mysterious Eastern potentates.

Like other illustrations which did refer to specific texts, this one allowed Rockwell to concentrate on something other than a simple, easily readable gag. *Checkers* (p. 20), for the *Ladies' Home Journal*, is a meticulous study of light effects and subtle gestures, impossible in a cover picture. It stands in marked contrast, for instance, to a more typical Rockwell cover entitled *Barbershop Quartet* (p. 17) in which the barbers and their clients play to the audience in a broad, rhetorical manner, with a copy of the naughty, men's-only *Police Gazette* prominently displayed in the foreground to underscore the humor.

His time in Hollywood had important artistic consequences: Rockwell was becoming a master of theatrical and cinematic effects. His covers and occasional illustrations took on the appearance of moments from the movies, when the actors face the camera directly, when directors compose their scenes to underscore key moments in the script, when overstated costuming allows the audience to identify the genre at a glance. Rockwell's trip to Hollywood in 1930 cemented the connection between his art and the art of the filmmaker.

The *Post* cover that resulted from his California adventure (signed "Norman Rockwell, Hollywood") shows Gary Cooper (p. 16) in the process of being made up for his role in "The Texan," a Western then in production on the Paramount lot. The idea preceded Norman's trip to the studio, but he was thrilled to have the handsome Cooper as his model. That the rugged star might need the painted lips of a starlet was the joke behind the picture. But the details say a great deal about Rockwell's approach to creating an iconic image. The items in Cooper's wardrobe—the Stetson, the spurs, the boots, the chaps, the six-shooter—seem a little larger than life, to signify the look of a typical backlot "oater."

Costume makes the character, as so often happens in Rockwell's circumscribed world, where a neighbor or a professional model can readily turn up as a farmer (p. 25), a bobby-soxer (p. 28) or a semi-lecherous trucker (p. 29) by a simple change of clothes. And just as the objects placed head-high in Rockwell's work often suggest the innermost thoughts of his sitters, so Cooper is silhouetted before a battered costume trunk, revealing his status as maker of celluloid images (in this case, "The Texan," chalked on the blackboard tacked to the trunk).

Both Cooper and the make-up man painting his lips are artists, then—popular artists, like Norman or the colonial sign painter (pp. 22–23). For the rest of his career, Rockwell would return, time and again, to examine and celebrate artists operating in humbler branches of the painter's profession. Sign painters, billboard artists, tattoo artists (p. 41), men painting carousel horses, and Norman himself, laboring over his own self-portrait for a *Post* cover (p. 78), would define the vast range of popular, public, commercial, utilitarian art, in which he was proud to play a major role.

His recurring interest in defining his proper place in the world of art made Rockwell increasingly restless, however. He went to Europe four times in the 1920s and 30s—and even took a stab at the "modern" art in vogue there. Lorimer had retired from the *Post*; in the editorial offices of his most important client, nothing seemed quite the same. Finally Norman took Mary and the boys and

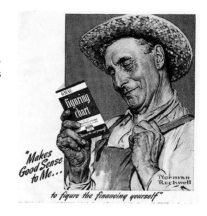

"Makes Good Sense to Me …," 1940
Ad for General Motors time-payment plan, reproduced in the *Saturday Evening Post*, November 9, 1940, p. 47

A Regionalist theme: the kindly American farmer, in his trademark overalls and straw hat.

ILLUSTRATION PAGE 24:
Worth Stopping For, 1937
Ad for Beech-Nut Gum and Candy, reproduced in *Esquire*, May 1, 1937, p. 11
Oil on canvas, previously mounted on board, 56 x 111.5 cm
Private collection

ILLUSTRATION PAGE 28:
Girl Reading the **Post**, 1941
Painting for *Saturday Evening Post* cover, March 1, 1941
Oil on canvas, 89.5 x 69 cm
San Francisco, CA, Collection Diane Disney Miller

ILLUSTRATION PAGE 29:
The Flirts, 1941
Saturday Evening Post cover, July 26, 1941
Stockbridge, MA, The Norman Rockwell Museum

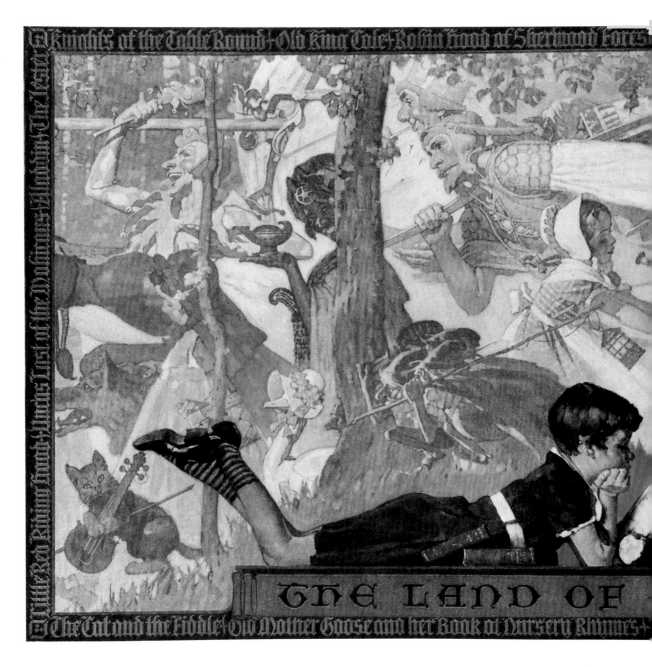

"I just loved to paint costumes But I don't
any more. People don't enjoy them."
NORMAN ROCKWELL

escaped to the countryside, to his own self-defined "land of enchantment." In 1939, they settled in rural Arlington, Vermont. For Norman, the New England landscape and the friendly Yankee townsfolk gave him a fresh sense of history and community. In addition, Vermont provided a camaraderie and support he had not known in fashionable New Rochelle. Mead Schaeffer, John Atherton, and George Hughes—friends and fellow illustrators—had also come to Arlington to raise their families. Their wives and children became Rockwell's models: one of the Schaeffer girls is the haughty blonde in *The Flirts* (p. 29). As the world

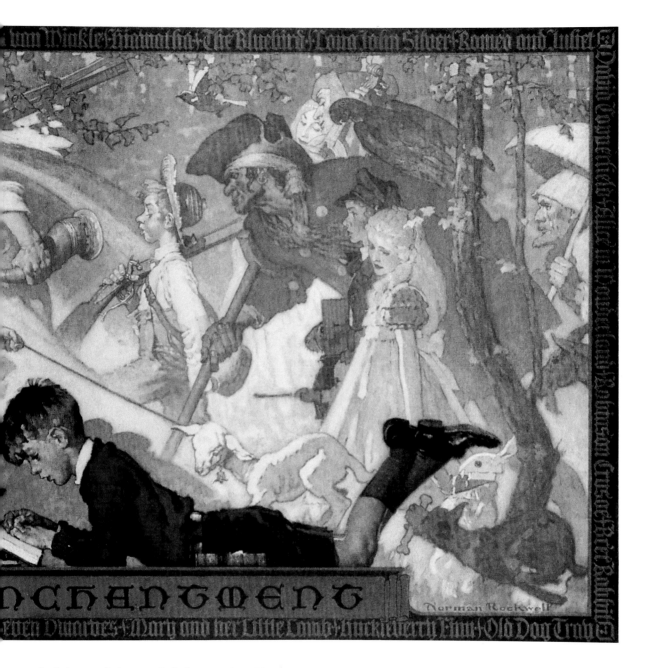

edged closer and closer to the holocaust of World War II, Rockwell basked in the warmth of their company and found, at last, the home place for which he had longed.

The Land of Enchantment, 1934
Illustration for *Saturday Evening Post*,
December 22, 1934, pp. 18–19
Oil on canvas, 94 x 193 cm
New Rochelle, NY, New Rochelle Public Library

Rockwell's delightful practice of showing the visions in the mind's eye of his protagonists is especially apt in this double-page work, which accompanied a line of poetry in the *Post*.

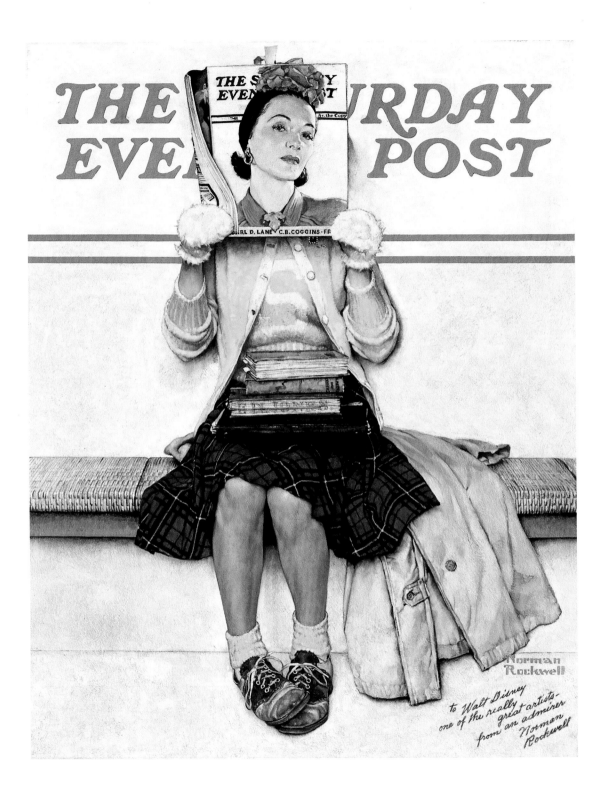

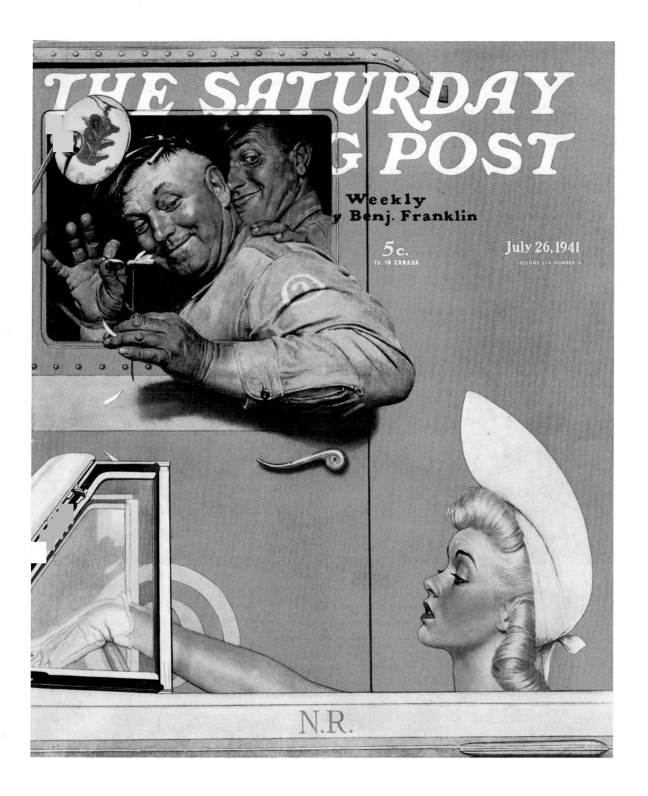

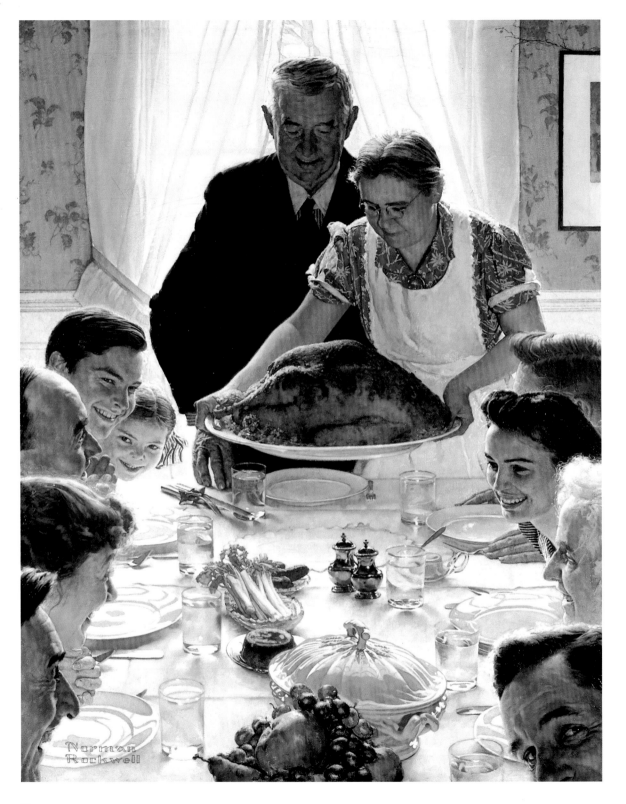

Patriotism in paint: Norman Rockwell goes to war

From his rural refuge in Arlington, Norman continued to produce a flood of covers, ads, and illustrations. He settled down to enjoy his new friends and their families, a new cadre of potential models, and the annual cycle of local events, ranging from dances and suppers at the Grange Hall to old-fashioned New England town meetings in which the issues of the day were thrashed out and settled democratically. Rockwell's commissions and his travels to California continued unabated, despite the growing threat of global warfare. Somehow, from the safety of his home base in Arlington, Vermont, danger seemed very far away.

Rockwell's last prewar cover for the *Post*, completed months before its ultimate publication on December 20, 1941, pictured a newsstand aglow in the darkness of a snowy urban street (p. 31). Inside sits an old woman, knitting away in perfect peace. She has decorated her little shop for the Christmas season with a wreath, a string of tinsel, and a red paper bell. But the real decorations are supplied by copies of the *Saturday Evening Post*, hung above and around her sales window. And every one of them shows exactly the same scene that the cover depicts: the little newsstand, aglow with warmth and light in the cold winter night, surrounded by tinsel, a bell, and *Post* covers showing the little newsstand . . .

The effect is to multiply the feeling of coziness, of shelter from the troubles of the cold, wide world outside the warmth of the woman's little nest. This rather ordinary Christmas cover, coming only weeks after the bombing of Pearl Harbor, carries an unintended but powerful sense of reassurance. There is light in the darkest night, peace and goodwill in the most mundane corners of a troubled world.

During World War I, when he had addressed the subject of American combatants in his commercial work, Rockwell had carefully avoided violence and bloodshed. His recruit was the typical American boy, grown to manhood and steeped in virtue. He brings gifts to children displaced by warfare. He is the sturdy lad Rockwell pictured in his annual calendar illustrations for the Boy Scouts of America, minus the short pants and the neckerchief (p. 33). "I had done pictures of the doughboys in France, but it had all been fakery," he confessed, "dressing models in costume—soldiers' uniforms." Now, Rockwell steeled himself to depict war as it really was.

A retired Army colonel who lived in Arlington arranged to have a machine gun crew sent to Vermont for Norman's inspection. A young gunner raised no

News Kiosk in the Snow, 1941
Saturday Evening Post cover, December 20, 1941
Stockbridge, MA, The Norman Rockwell Museum

At the time Rockwell actually painted this cover picture, the first draft call for World War II had gone out and defense bonds were being sold. These preparations for war are represented by the red cross and the bond poster at the left side of the window.

ILLUSTRATION PAGE 30:
Freedom from Want, 1943
Illustration for *Saturday Evening Post*, March 6, 1943, p. 85
Oil on canvas, 116 x 90 cm
Stockbridge, MA, The Norman Rockwell Museum

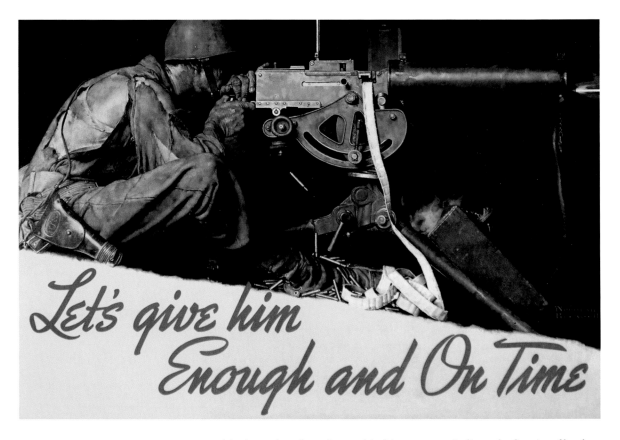

Let's give him
Enough and On Time

Let's Give Him Enough and On Time, 1942
Painting for U. S. Army poster
Oil on canvas, 106.5 x 127 cm
Washington, DC, The National Museum of the
U.S. Army, Army Art Collection

Rockwell's most belligerent wartime image,
this was routine home front rhetoric: the battle-
weary soldier, down to his last round of ammo,
appeals to the public for support.

objections when the artist tore his shirt to rags, to indicate the ferocity of battle,
but insisted that his weapon be shown in perfect, regulation order in Rockwell's
poster for the U. S. Army (p. 32). By some accounts, Rockwell had wanted to
show the soldier aiming his gun at the viewer. The effect would have been ag-
gressive and accusatory, in the style of Montgomery Flagg's pointing Uncle Sam,
the famous "I Want You" recruiting poster from World War I. In the end, how-
ever, he chose a less dramatic profile view of the steadfast gunner, who is down
to his last round of ammunition. The message is clear: *Let's Give Him Enough
and On Time*.

By 1942, when the poster was designed, Norman had been painting *Post* cov-
ers for 26 years. Every year, the pressure was greater. Would a particular cover sell
magazines? Was there another young artist, a better one, waiting in the wings to
dethrone him? The *Post* ran through several editors in rapid succession after
Lorimer's retirement: each one had fresh expectations and demands. Would the
magazine fold entirely? Was his stuff as good today as it was 26 years ago? And
then there were the advertising agencies dangling long-term contracts which
would leave Rockwell in a perpetual dither over deadlines on pictures designed
to sell canned vegetables and Coca-Cola.

These problems, in addition to the anxieties bred by war, made Norman
Rockwell reevaluate his talent and his career. Could he paint a "Big Picture," a
real painting, noncommercial, with an important and universal meaning? The
immediate inspiration for this shift in focus was the Atlantic Charter, promul-
gated by President Franklin Roosevelt and British Prime Minister Winston

Churchill in August of 1941. The Charter would become the keystone of the American war effort, a declaration of the principles upon which a just world order in the postwar future would rest. The sentiments expressed were noble but, to Rockwell's mind, a little too noble to be understood readily by the average American.

Roosevelt, in his annual address to Congress that year, articulated the Four Freedoms essential to the spirit of the Charter. Again, however, freedom from fear and want, freedom of speech, and freedom to worship seemed, in the abstract—without concrete examples—too exalted to be meaningful and urgent at the level of everyday experience. Could Norman, perhaps, "illustrate" these concepts in a pictorial language that would render them vital and real to his fellow Americans? Could this be the key to his "Big Picture"?

In his autobiography, Rockwell describes restless nights, tossing and turning and worrying over how to paint the Four Freedoms. He sketched. He brooded. And finally one night, at 3 A.M., after a town meeting, he sat up in bed with a start and knew he had it. "My gosh, I thought, that's it. There it is. Freedom of Speech. I'll illustrate the Four Freedoms using my Vermont neighbors as models. I'll express the ideas in simple, everyday scenes. Freedom of Speech—a New England town meeting. Freedom from Want—a Thanksgiving dinner." Rockwell was so excited that he got on his bike, rode over to Mead Schaeffer's house, and woke him up to share the good news.

A couple of days later, Norman and "Schaef" set off to Washington to offer the idea to the government. At the War Department, an undersecretary turned down the concept on the grounds that everybody was too busy to print up posters, even if they were by Norman Rockwell. Official after official turned the pair away, although the pictures were being offered free of charge. At the Office of War Information, the fellow in charge of pictorial propaganda wasn't interested, either. "The last war you illustrators did the posters," he said. "This war we're going to use fine arts men, real artists."

In fact, during World War I, a Division of Pictorial Publicity had been formed, under the direction of Charles Dana Gibson, to recruit young men for the military through the use of posters. The group met weekly at Keene's Chop House in New York City to plot strategy and the membership included most of the best-known illustrators of the day, including James Montgomery Flagg and Howard Chandler Christy (who judged the Miss America contest with Rockwell in 1922). This celebrated example of patriotic action on the part of his idols probably motivated Rockwell's generous gesture. But the sharp hierarchical distinction between artists and illustrators drawn by the OWI functionary showed that times had changed. And it surely rankled an artist—or was he merely an illustrator?—bent on creating a "Big Picture" for his country.

In the end, it was commerce that saved the Four Freedoms. Once the *Post* heard of their shabby treatment in Washington, the staff arranged to have Rockwell's planned canvases printed at large scale on inside pages, suitable for framing and accompanied by essays on each of the four topics by some of the most illustrious literary talents of the period. Schaeffer, meanwhile, was contracted for a total of 14 covers depicting members of the armed forces carrying out their duties. But the Four Freedoms pictures, heavily promoted by the *Post*, became America's foremost icons of World War II.

Eventually, to "sell" the war effort to a nation which had lost more than 20,000 boys by early 1943, when the Rockwell paintings began to run in the *Post*, the OWI printed an initial run of 2,500,000 posters. Rockwell took to the road

"Most of the pictures I did during the war took their subjects from the civilian wartime scene— the armchair general, women war workers, the ration board. That was what I knew about and what I painted best."
NORMAN ROCKWELL

A Scout is Loyal, 1942
Painting for Boy Scouts of America 1942 calendar; also reproduced as cover for *Boys' Life*, February 1942
Oil on canvas, 99 x 73.5 cm
Private collection

Lincoln, Washington, the Bill of Rights, the flag, and the eagle all stand behind the scout's loyalty to country. His pack and his uniform, with its badges and insignia, suggest that this young man is destined for the military.

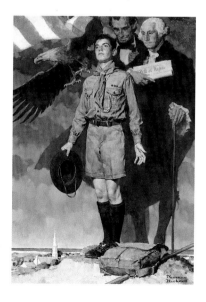

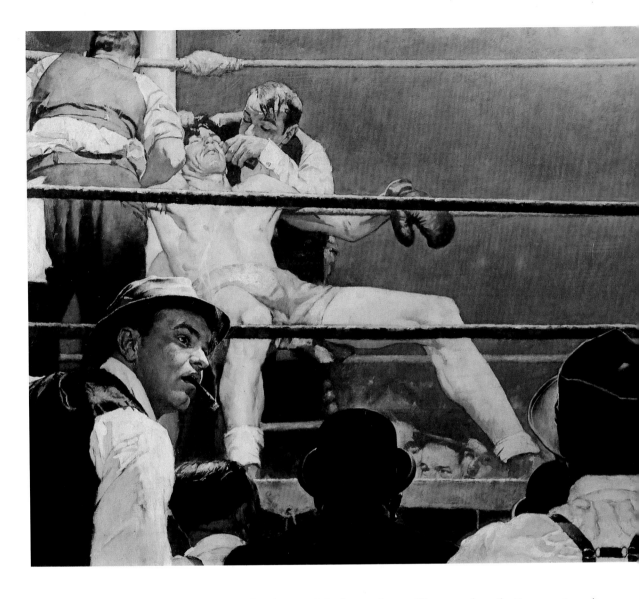

on a bond tour to help finance the war. Film crews from the Paramount movie newsreel came to Arlington to film Rockwell pretending to paint *Freedom to Worship* (p. 39) as his original models assumed poses before him. The paintings went out on tour, too. The "Big Picture" had become four big pictures, endlessly reprinted and still venerated by Americans today.

The idea of using ordinary Americans to represent the freedoms specified in the presidential address came easily. The execution did not. Norman began the series with the town meeting he had attended on the evening of his late night visit to Schaeffer. On that occasion, Jim Edgerton had spoken forcibly on the issue of the hour: the construction of a new Arlington high school. Apparently, Edgerton found no support for his views. But his neighbors had listened respectfully. There were no interruptions, no catcalls. This was *Freedom of Speech*, at a grassroots level!

In the first of several attempts to capture that scene, Rockwell looked down on the speaker and a large section of his audience from an elevated angle. The artist rejected this version. "It was too diverse," he decided. "It went every which way and didn't settle anywhere or say anything." The model for the central figure, Carl Hess, owner of the local gas station, is seen from just below eye level in the version that would appear in the *Post* in February of 1942—the first of the series (p. 36). That altered perspective was the solution to Rockwell's dilemma. The head and shoulders of the speaker were now spotlighted against the dark, blank background of a chalkboard. Clearly, he was the subject of the painting and the cluster of attentive citizens, reduced in size and subordinated to his towering form, were mere grace notes in a tightly focussed composition. A mark of Norman Rockwell's personal stake in getting the picture right appears along the far left edge of the picture, where a fragment of a self-portrait, including one

Strictly a Sharpshooter, 1941
Illustration for *American Magazine*, June 1941, pp. 40–41
Oil on canvas, 76 x 180.5 cm
Stockbridge, MA, The Norman Rockwell Museum

A rare example of a violent subject by Norman, this work illustrated a short story by D. D. Beauchamp. The only "real" figure in the picture is the fighter in his corner at the left. The blonde, for example, is Elizabeth Schaeffer, wife of Mead Schaeffer, the Arlington illustrator who became Norman's closest friend and supporter during World War II.

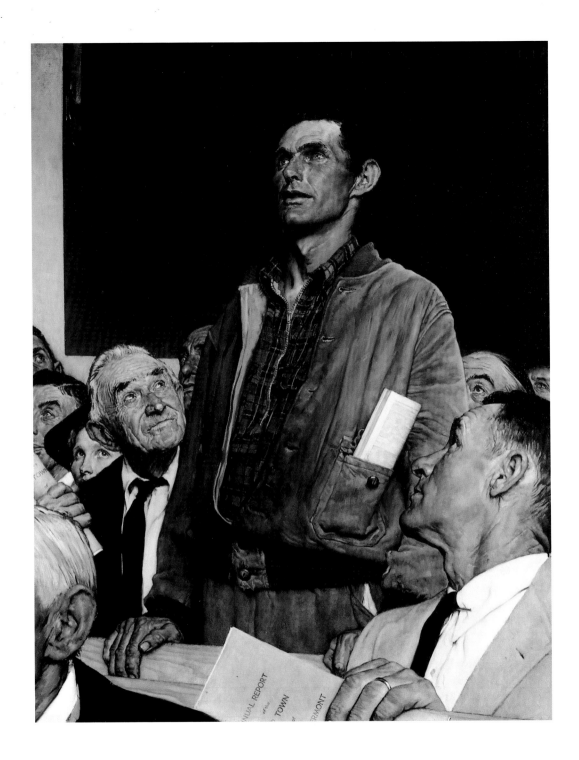

Freedom of Speech, 1943
Illustration for *Saturday Evening Post*, February 20, 1943, p. 85
Oil on canvas, 116 x 90 cm
Stockbridge, MA, The Norman Rockwell Museum

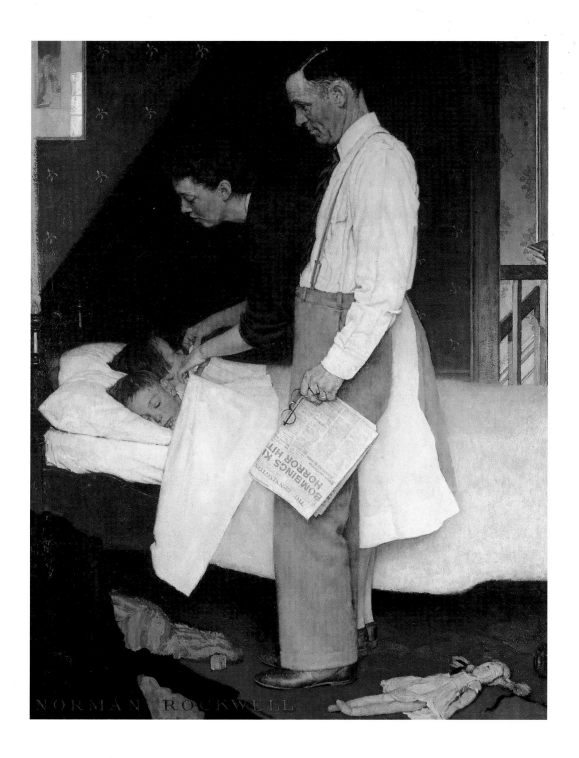

Freedom from Fear, 1943
Illustration for *Saturday Evening Post*, March 13, 1943, p. 85
Oil on canvas, 116 x 90 cm
Stockbridge, MA, The Norman Rockwell Museum

omniscient, unblinking eye, appraises the scene, as if to endorse this, the definitive solution to the problem Rockwell had set for himself.

Freedom to Worship (p. 39), the second in the series, proved even harder to represent. Religion, Rockwell knew, was a touchy subject. What would strike one viewer as deeply meaningful might be sacrilicious to another. At first, he tried to emphasize religious tolerance with a smalltown barbershop scene, in which a varied cast of characters, including a genial Irish-Catholic priest, a Jewish customer in the chair, a Yankee barber, and an African-American man swap stories in perfect amity. The problem was that he had created ethnic stereotypes which may or may not have been pertinent to religious belief. The large oil was almost finished when Rockwell realized his mistake after showing the work around the neighborhood: nobody, it seemed, connected the image with the declared theme. So he abandoned that canvas in favor of a close-up group portrait of seven individuals of various skin tones, some carrying rosaries or service books, all united in prayer. As if diversity and freedom were not evident from the image itself, Rockwell inscribed this legend in golden letters at the top of the canvas: "Each according to the dictates of his own conscience." He had heard that phrase somewhere, he said.

The remaining two pictures came more easily. Number Three, *Freedom from Want* (p. 30) depicted his own family—or part of it— gathered around the table for Thanksgiving dinner. He had the Rockwell cook, Mrs. Wheaton, photographed as she presented the turkey, hot from the oven. ("She cooked it, I painted it, and we ate it," Rockwell remembered. "That was one of the few times I've ever eaten the model.") Mary Rockwell, Norman's wife, is the woman on the left side of the table; his mother is the elderly lady seated across from her. Everybody else was an Arlington personality, chosen to fill out the scene according to Rockwell's mysterious and unfailing sense of what face belonged in what scene. The last of the Four Freedoms pictures was painted during the Battle of Britain—the horrific bombing of London—the event alluded to in the fragmentary headline of the newspaper held by the father watching his children slumbering in their upstairs bedroom (p. 37). The rag doll abandoned on the floor just behind his feet echoes the posture of the sleeping children but, in her limp, discarded form, also alludes to the European children who did not enjoy the safety of a warm bed guarded by caring parents.

The Four Freedoms series was, Norman believed, "a job that should have been tackled by Michelangelo." In retrospect, despite universal praise for his pictures, Norman thought they might have been better. Especially troublesome to him were *Freedom from Fear* and *Freedom from Want*. They had no "wallop," he said. Perhaps they came too easily. Or perhaps they were a little too self-congratulatory. The Thanksgiving scene, for example, although austere by 21st-century standards, was cruelly overstuffed with food when compared with the tables of British and French families, faced with rationing and privation. As for the bedroom scene, Rockwell had pictured it in his mind's eye after hearing radio reports, night after night, about the bombing of London. There was a tone of smugness in his rendition of American children enjoying the blessings of peaceful repose when their counterparts in the Allied nations were not.

Today's critics might more readily question the artist's decision to make *Freedom to Worship* so different from the other paintings. The rest are genre paintings, showing slices of American life in their proper settings—scenes which correspond to the principles defined by F. D. Roosevelt. But the religion panel is almost an icon. There is no setting or context presented. The portrait heads are

"There it is. . . . I'll illustrate the Four Freedoms using my Vermont neighbors as models, I'll express the ideals in simple, everyday scenes."
NORMAN ROCKWELL

Freedom to Worship, 1943
Illustration for *Saturday Evening Post*, February 27, 1943, p. 85
Oil on canvas, 117 x 90 cm
Stockbridge, MA, The Norman Rockwell Museum

This is the least successful of the works in the series. It gave Rockwell the most trouble and illustrates his difficulty in finding a pictorial language to match his ambition to paint a "Big Picture." Will Durant, a best-selling popularizer of historical and philosophic works, wrote the essay.

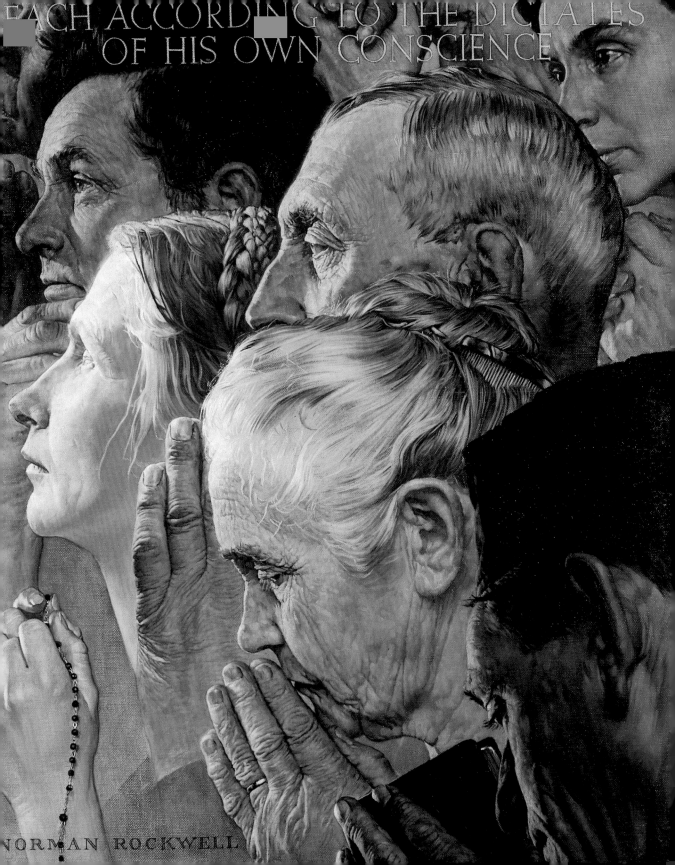

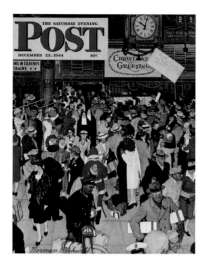

Union Station, 1944
Saturday Evening Post cover, December 23, 1944
Stockbridge, MA, The Norman Rockwell
Museum

ILLUSTRATION PAGE 41:
Tattoo Artist, 1944
Painting for *Saturday Evening Post* cover,
March 4, 1944
Oil on canvas, 109.5 x 84 cm
Brooklyn, NY, Brooklyn Museum of Art, gift of
the artist

Rosie the Riveter, 1943
Saturday Evening Post cover, May 29, 1943
Stockbridge, MA, The Norman Rockwell
Museum

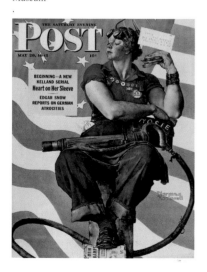

crammed together in an indeterminate space, like saints floating on the page of a mediaeval manuscript. And the added legend, interpreting the meaning, is Rockwell's own admission that, without the words, the significance of the image would be difficult, if not impossible, to grasp. Illustrators, on most occasions, interpret the ideas contained in a text. Here, the text, lettered in gold, is forced to interpret the image.

Rockwell had devoted seven months to the Four Freedoms. At the end of the ordeal, he was bone tired and troubled by a sense that he had not quite hit the mark—that the "Big Picture" had somehow eluded him. The series "sucked the energy right out of me," Norman wearily admitted. But, when he resumed his normal routine, Rockwell's wryly humorous *Post* covers had never been better. His brush with the "Big Picture" resonated in the monumental *Rosie the Riveter* of May, 1943 (p. 40 bottom). Perched on a pedestal with the Stars and Stripes flying behind her, Rosie is Michelangelo's Prophet Isaiah from the Sistine ceiling dressed up as an American patriot-warrior, a goddess of the home front, armed with a massive rivet gun, and a ham sandwich. Beneath one imposing foot Rosie crushes a copy of Hitler's *Mein Kampf*. Above her head, a tangle of wires and cables forms a halo, elevating the American girl who has taken the place of a man in the aircraft industry to the status of roughhewn sainthood. In contrast to the reverential *Freedom to Worship* (p. 39), the cover illustration manages to evoke American values in a direct, down-to-earth manner which continues to make Rosie a powerful symbol for working women 60 years after the fact.

The "Big Picture" is also an issue in *Tattoo Artist*, a *Post* cover from 1944 (p. 41). In many ways, the composition resembles *Rosie the Riveter*. Like Rosie with her flag, the tattoo operator sits on a pedestal formed by a metal tool case in a place defined solely by "art"—his art, in the guise of a giant sample sheet of available designs, both patriotic and sentimental. Norman's friend, Mead Schaeffer, is the tattooist, and he is in the process of crossing out the names of girls already displayed on the capacious arm of a sailor (Arlington Grange official, Clarence Decker) to add that of the latest one-and-only. The design pokes fun at the reputation of sailors on shore leave. And it raises the issue of "art" once again. Are Schaef and Norman "real artists," of the type Washington was prepared to hire, or popular artists, mere illustrators, like the tattooist, happy to be crowd-pleasers with the common touch? In this cover, Rockwell seems to be breathing a sigh of relief to be back in the ranks of sign painters, tattoo artists, and magazine illustrators who make real pictures for real people.

Another revealing wartime cover graced the Christmas issue of the *Saturday Evening Post* in 1944 (p. 40 top). The setting is Chicago's North Western Railroad Station. Under the great clock, American life begins to return to normal as World War II comes to a close. Santa rings bells for charity. Passengers stream past, burdened with holiday presents. A genial drunk staggers home with a Christmas tree, under the censorious gaze of two nuns. Right under the magnificent clock, Rockwell staged a reunion between a beautiful redhead and a Navy lieutenant, and scattered throughout the rest of the picture, men from all the armed forces find their happy families at last. Even Norman Rockwell got into the act, posing for the gentleman waving a piece of paper in the upper right section of the crowd. For Norman, a period of dramatic change came to an end with the end of the war. But the lessons of the Four Freedoms would enrich his work and fuel his ambition for decades to come.

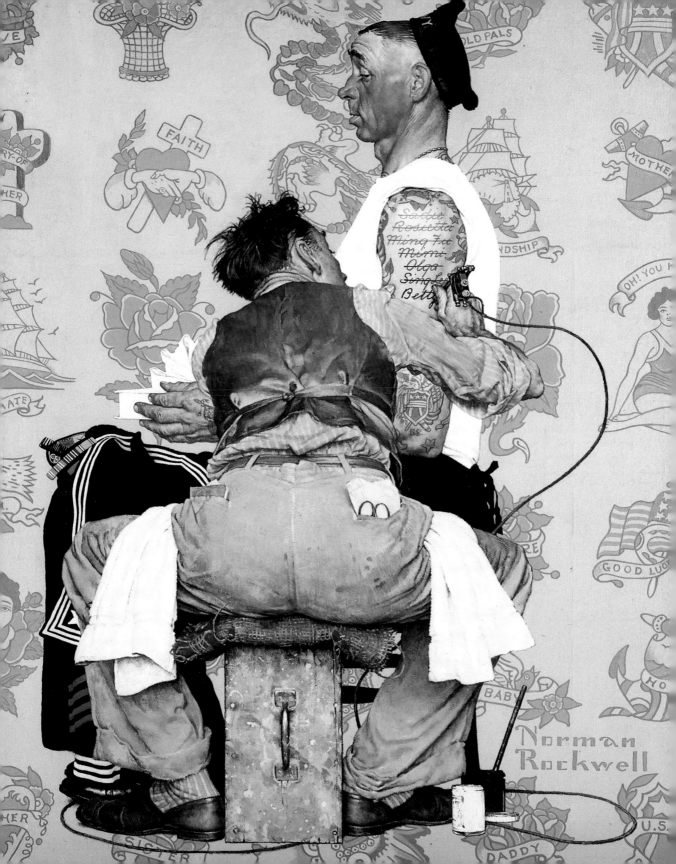

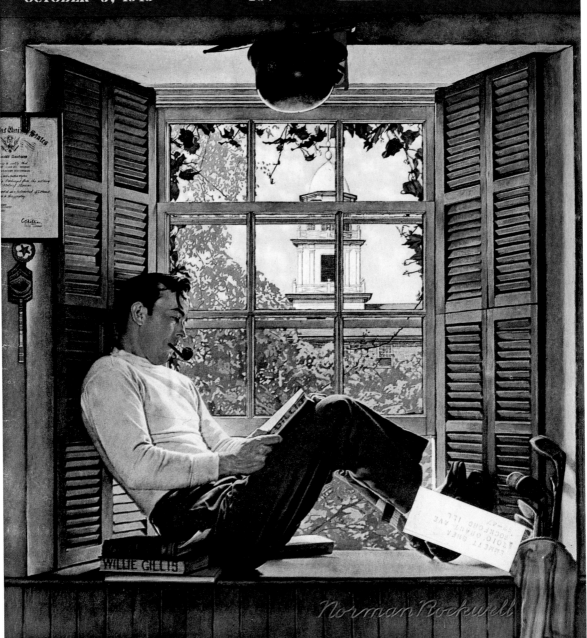

THE SATURDAY EVENING

POST

OCTOBER 5, 1946 10¢

THE CASE OF
ERLE STANLEY GARDNER
By ALVA JOHNSTON

WASHINGTON, D.C.
By GEORGE SESSIONS PERRY

WILLIE GILLIS

Norman Rockwell

Mr. Rockwell paints a magazine cover

In addition to *Rosie the Riveter* (p. 40 bottom) and the Four Freedoms, Norman also produced an extraordinary group of eleven *Saturday Evening Post* covers depicting a single boyish GI and his wartime adventures. He called his everyman Willie Gillis. Willie first appeared in October of 1941, several months before Pearl Harbor: a raw recruit, the innocent little fellow has just received a food package from home and is being pursued by a crowd of non-coms and enlistees, all eying his bundle hungrily. Rockwell studied the various Army uniforms at Fort Dix, but even before he went there on a research trip, he had already selected Robert Otis Buck as his Willie. Bob Buck, whom he spotted at a local square dance, was everybody's idea of a younger brother, or the kid down the street. Because Buck had been exempted from the draft for stomach surgery, he was apt to be available to pose. And when he finally joined up, Rockwell went on with the series anyway, using old photos for models.

Over the course of the next five years, Willie underwent the kinds of experience that typified the life of a youngster in the armed forces. He came home on leave. He attracted the attention of two glamorous volunteers at the USO. He read the hometown papers (from Arlington, Vermont, of course) while paring apples on KP duty. He shared a blackout shelter with a pretty miss and made friends with an Indian fakir. Meanwhile, back in Vermont, girls fought over his picture or missed the New Year's Eve dance because he couldn't be there. Willie Gillis, who was immediately adopted by the public as their own, made his final appearance in October of 1946 (p. 42). He is back home now, safe and sound, older and wiser, and going to college on the G.I. Bill.

The picture is a masterpiece of telling detail, in the tradition of Vermeer or Pieter de Hooch. Visible out the window behind Gillis is the bell tower of Middlebury College, which Rockwell visited in order to set the collegiate scene accurately. Above the window embrasure hangs a helmet and a bayonet; near Willie's head, his discharge papers and service insignia. But it is astonishing to learn that there is a photograph, almost identical to the finished picture, in which Rockwell himself plays Willie Gillis. Some details are missing or differently placed, but the golf clubs, the textbooks, and the shutters are all there, as is Norman's ubiquitous pipe, which Willie smokes in the final version.

The photograph demonstrates Rockwell's use of the camera, the dirty secret that illustrators had half-hidden for generations. Indeed, during the decades

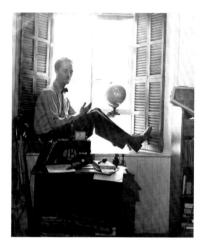

Rockwell as Willie Gillis, 1946

ILLUSTRATION PAGE 42:
Willie Gillis in College, 1946
Saturday Evening Post cover, October 5, 1946
Stockbridge, MA, The Norman Rockwell Museum

The props remind the reader of Willie's past and his future, but the strong composition is a result of the masterful orchestration of the flat angular areas of the picture: the window opening, the window panes, the shutters, the books, the paneling.

following World War II, Rockwell's work becomes more and more detailed, thanks in large part to photography. The backgrounds—like the Middlebury tower, shot under Rockwell's direction—are as active as the foregrounds. The result, paradoxically, is to flatten and abstract the image. Nor did Norman make any effort to hide his use of the camera. In fact, he spoke about it openly in the presence of students and told the nation everything in a popular book, *Norman Rockwell Illustrator*, published in 1946 by his friend Arthur Guptill.

By 1946, Rockwell's was a household name. The *Post* printed Rockwell anecdotes and reporters from other journals went to Arlington to record the doings of the family. The press sought out his opinion. He appeared in ads for paints and greeting cards. The accidental burning of his Arlington studio in 1943 was headline news. *Time* ran a lengthy profile of the artist. So did the upscale *New Yorker*. In the mid-40s, however, the community of illustrators was under serious attack from several quarters.

On the one hand, advertisers were using photography instead of illustration to sell their wares. Photos seemed more modern and, in the tradition of documentary photography, more honest. On the other hand, a select group of corporations embraced the fine arts as a merchandizing tool: well-known gallery artists spelled sophistication and chic. At the same time, the critical establishment had begun to embrace abstraction by denigrating the narrative art of realist painters and illustrators alike as "lowbrow" and outmoded. During this difficult period, Rockwell became the standard bearer for illustration, even though his own yearning for the "Big Picture" seemed to contradict this new emphasis on art-for-hire.

Preparatory sketches for **Fixing a Flat**, 1946
Crayon, 62 x 61 cm; 81 x 61 cm

Publication of Guptill's book *Norman Rockwell Illustrator*, with its long and admiring descriptions of Rockwell's technique, helped Rockwell articulate his own thinking about the meaning of his art. His honesty about the use of photos and his openness about technical matters disclose a born teacher, soon to became a mainstay of the Famous Artists School.

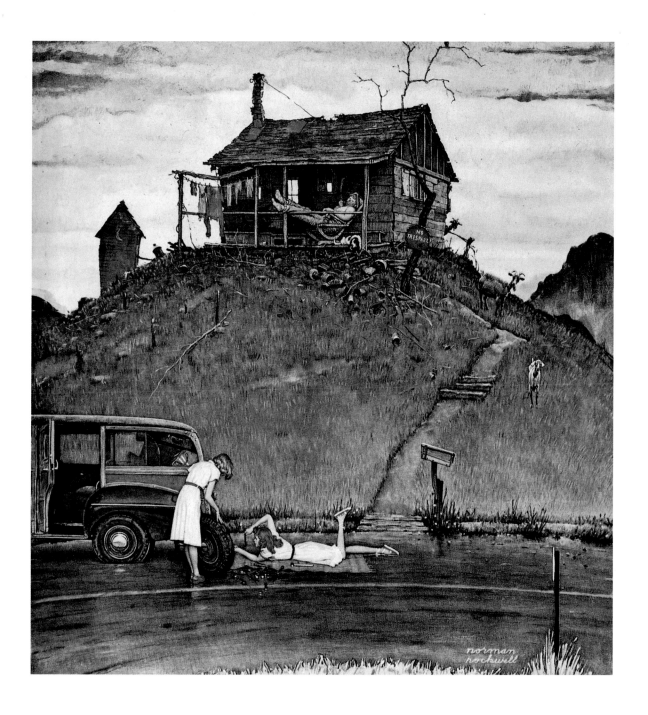

Fixing a Flat, 1946
Saturday Evening Post cover, August 3, 1946
Stockbridge, MA, The Norman Rockwell Museum

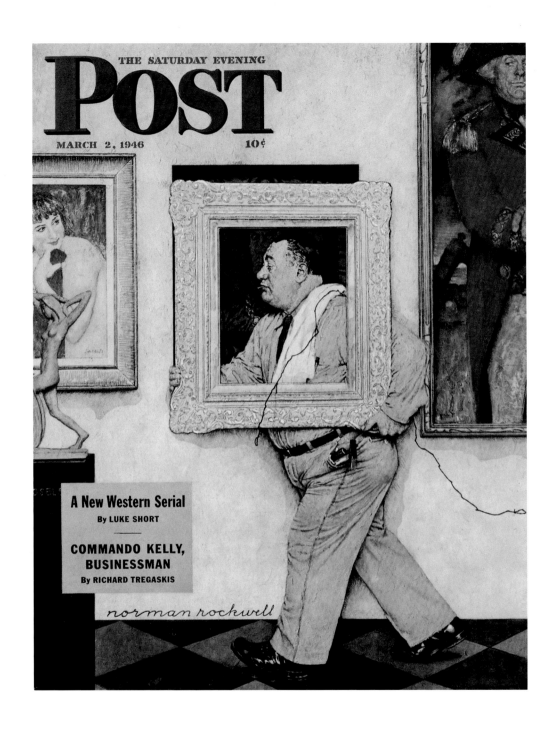

Framed, 1946
Saturday Evening Post cover, March 2, 1946
Stockbridge, MA, The Norman Rockwell Museum

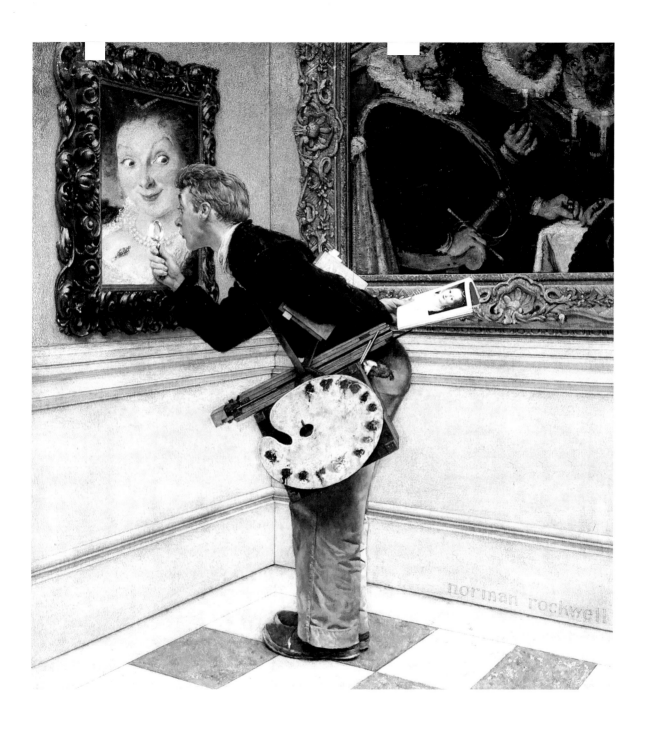

The Art Critic, 1955
Painting for *Saturday Evening Post* cover, April 16, 1955
Oil on canvas, 100.5 x 92 cm
Stockbridge, MA, The Norman Rockwell Museum

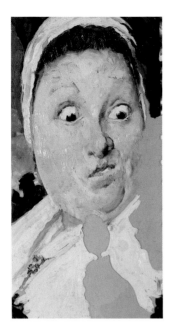

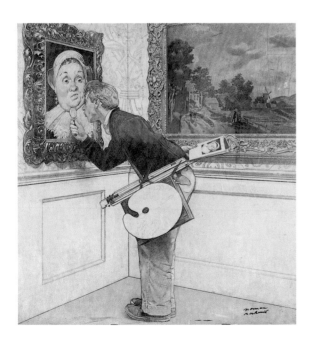

ILLUSTRATIONS PAGES 48/49:
Preparatory studies for *The Art Critic*, 1955
From top left to bottom right:
Oil on acetate board, three studies,
each 26.5 x 14 cm
Pencil on paper, 12 x 11 cm
Charcoal on board, 96.5 x 91.5 cm
Charcoal, 29 x 21 cm
Charcoal and pen on board, 29 x 20.5 cm
Pencil and charcoal on paper, 28 x 19 cm
Stockbridge, MA, The Norman Rockwell
Museum

Mary Rockwell posed for the figure in the
Rubensian portrait.

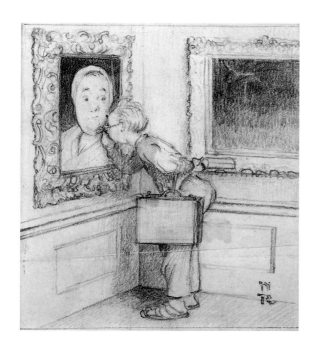

As a key figure in the debate, Rockwell took an active role in the creation of the Famous Artists School, Inc., founded in 1947 in Westport, Connecticut, by Albert Dorne. This was a correspondence course. The twelve original stockholders and faculty members, including Norman and his neighbor and sometime collaborator John Atherton, contributed to step-by-step textbooks on how to produce covers and ads. They also graded and corrected work sent in by students, offering counsel and encouragement. In lessons like "How I Make a Picture," big-time illustrators shared the tricks of the trade with eager newcomers, jobseekers who believed in the purposeful, popular art their successful elders had championed.

Arthur Guptill's book offers a similar course of instruction in Rockwell's methods of picture-making. Chapter Two, for instance, answers the layman's most frequent question—"Tell me, Mr. Rockwell, how *do* you paint a *Post* cover?"—with an annotated sequence of sketches, studies, and photographs, leading up to a completed painting reproduced on the cover of the *Post* on August 3, 1946 (p. 45). The idea was simple enough: two teenage girls trying to fix a flat tire while a loafer looks on idly from the porch of a tumbledown shack. But the execution was painstaking and complicated.

The first step, and often the most difficult, was finding an idea and getting it approved by Ken Stuart, the current editor of the *Post*. Stuart, who was far more demanding than Lorimer had been, insisted on Middle American subject matter,

Norman Rockwell Painting **The Soda Jerk**, 1953
Oil on board, 11 x 16 cm
Private collection

Rockwell managed to conjoin portraits of himself and his son in one tiny, intensely personal image.

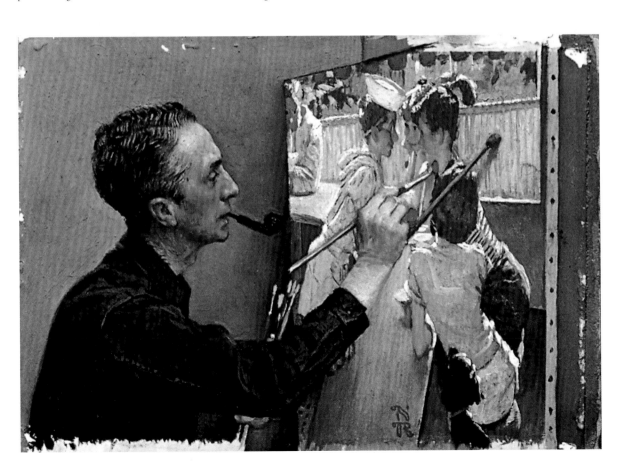

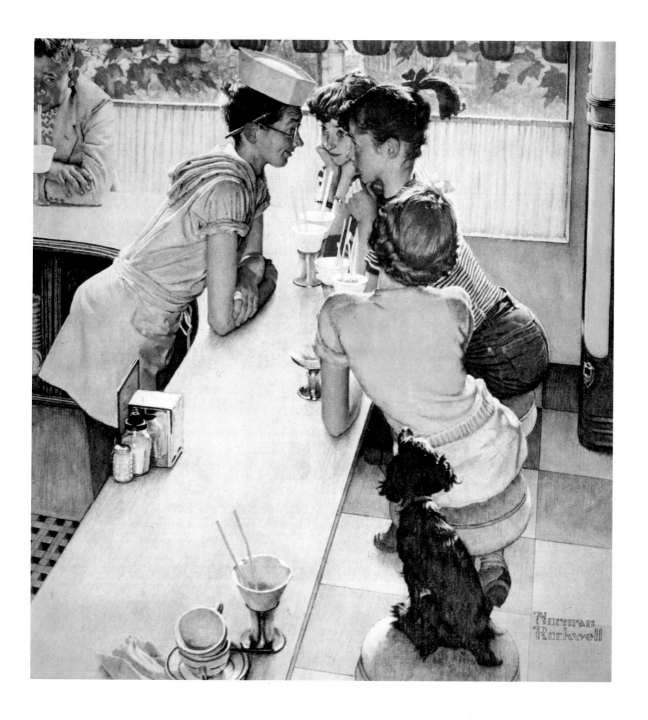

The Soda Jerk, 1953
Saturday Evening Post cover, August 22, 1953
Indianapolis, IN, The Curtis Publishing Company

treated in some detail. And it is possible that Rockwell's meticulous working methods of the 1940s, as well as his increasing reliance on photography, stemmed as much from the *Post* as they did from his personal bent. In any case, after preliminary approval, the next step was scouting for props and having his assistant, Gene Pelham, take black-and-white photos of goats, shacks, and the other details he found, including a new Ford station wagon, borrowed from a Vermont dealer. The photographs were not artistic masterpieces in their own right and Rockwell warned his reader not to use them "until he has learned to draw and paint extremely well without them." But photos were vital aids or tools for capturing "transient effects, difficult poses, and subject matter far from the studio."

In the meantime, Rockwell found the stars of his show: Mead Schaeffer's daughters, Lee and Patty, the dog, and the loafer. Now came a revised study in charcoal and another, more dramatic version, both done on tracing paper; large crayon studies of the composition and the details; smaller color studies; and finally, a charcoal layout drawing, exactly the size of the finished work, transferred to the canvas by means of a projector (Rockwell preferred a Balopticon), often by the faithful Pelham. Only then did the work of underpainting, varnishing, and laying in the colors—or actually painting the picture—begin.

There were many factors to keep in mind along the way. The audience, he learned from the marketing division of the *Post*, needed to "get" the story within two seconds, or the sale was lost. That meant exaggerating facial expressions, the gait and girth of key figures, and items like the old-fashioned outhouse adjacent to the loafer's cabin. But he made few aesthetic concessions to the fact that the audience would be seeing a mechanical reproduction rather than an oil-on-canvas original. Instead, he treated his picture as though it were an independent painting, especially in the case of the looser color studies that preceded the canvas ultimately shipped to Philadelphia. One recent Rockwell biographer has observed that these studies began to attract collectors in the 1940s for their own charm, especially after the studio fire destroyed some of his earlier work.

The finished product during the postwar years had an unprecedented richness and complexity, as if the loss of his artistic past had freed Rockwell somehow. At the same time, this "new" Norman Rockwell became openly concerned with defining the work of art in relationship to his own commercial picture-making. One of the covers he showed Guptill pictured a chubby little preparator toting an ornate frame through a museum (p. 46). The preliminary designs that appeared in *Norman Rockwell Illustrator* begin with a Frenchified artiste (with dog) carrying an empty frame, which also frames his head. In the next version, a setting has been added—a museum. But the *Post* cover, as published in March, 1946, has changed substantially.

First, the figure is shorter and fatter, for humorous effect. Second, the works of art hanging on the wall behind him are responding to his presence with varying degrees of amusement and disapproval: how dare this little person frame himself like us? Finally, the floor is tipped up, parallel to the picture surface, and finished in a checkerboard pattern of tiles which serves to iron out the space until the "picture"—the little man in his uniform—becomes as flat as the paintings on the wall. As if to emphasize the process, Rockwell adopts a large flowing script for his signature and inscribes it on the wall, so the illusory space and the painted surface become one and the same thing. This was a strategy adopted by Picasso and the American Stuart Davis to challenge the illusionism dominant in Western art since the Renaissance. Here, Rockwell deploys the device in a museum full of Baroque portraiture and Impressionist nudes. His challenge to the

Song of Bernadette, c. 1944
Poster-ad for 20th Century-Fox movie, reproduced in the *Ladies' Home Journal*, January 1944, p. 79

Although Rockwell was a frequent visitor to California's movie colony, he made this publicity portrait of Jennifer Jones in costume from a photo supplied by the studio. It was "run in magazines, newspapers and on theater posters," said the artist. "I was told that it covered the entire wall of one eight-story building."

The Swimmer, 1945
Saturday Evening Post cover, August 11, 1945
Stockbridge, MA, The Norman Rockwell
Museum

Rockwell's comment on this work to Guptill was
simply that, because he had to paint the picture
in March, he couldn't pose the model for his
traveling salesman—George Zimmer—in the
water of a Vermont swimming hole. He did have
the scene photographed, however; the low angle
puts the emphasis on the flat surface of the con-
crete wall. The theme reprises a favorite subject
of his early career. Rockwell's cute kid has grown
up!

world of fine art could not be more overt; the little fat man reverberates with
memories of his quest for the "Big Picture."

The Art Critic of 1955 (p. 47), another Post cover based on the same idea of fig-
ures in paintings looking back at the museum-goer, put his own son Jarvis, then
an actual art student, in the role of a young painter inspecting the pearls on the
bosom of a Rubensian beauty hanging in a museum. Numerous sketches, stud-
ies, and photographs show the evolution of this concept from a "beatnik" in a
museum to a quasi-comic meditation on art and illusion. The center of the pic-
ture is occupied by the artist's palette, the mark of his profession. And the reality
of the boy with his magnifying glass has been carefully subordinated to the paint-
ings themselves: the saucy lady looking down on the impertinent young man
with some amusement and the ruffled indignation of the Frans Hals worthies
peering at him from the adjacent corner. Again, Rockwell chooses the patterned
floor and an oversize signature emblazoned on the baseboard to make his point.
He has staked out a place for himself in the lofty halls of fine art.

In 1953, Norman borrowed his son Peter from his Vermont boarding school for
a weekend to pose for The Soda Jerk (p. 51). The completed cover is an amusing

Charwomen in Theater, 1946
Painting for *Saturday Evening Post* cover,
April 6, 1946
Oil on canvas, 108 x 84 cm
Private collection

The sharp angle of vision comes from the
camera; the intimate triangle formed by
the ladies and their mops comes from the
masters of the High Renaissance.

glimpse of the skinny teenage Adonis who becomes the idol of the female popu-
lation, so long as he controls the soda spigots. But it is impossible to ignore the
formal daring of the work. The countertop seems to rise up in one great vertical
swoosh, rather than pushing into depth, and the checkerboard floor makes little
effort to obey the time-honored laws of linear perspective. Even when the subject
is *not* art, then, Rockwell's compositions take a radical tilt toward the abstract.

In this instance, surviving photographic studies made that weekend show
that Rockwell had posed his son and several classmates leaning on a huge
expanse of white board and directed the photographer to shoot from a high
angle, producing the dizzying effect of spatial dislocation notable in the painting.
Furthermore, he then painted a self-portrait of the artist painting *The Soda Jerk*
(p. 50), in which the flatness of the counter area is even more apparent, as is the
surface of the work-in-progress, seen from a slight angle, with the right edge of
the canvas on display.

This growing preoccupation with craft, technique, and procedure, in addition
to his increased reliance on staging scenes in advance for the camera, account for
radical changes in Norman Rockwell's style in the wake of the Four Freedoms
series. These latest works are more detailed in the presentation of trimmings,
props, and settings, in line with his editor's new direction for the *Saturday
Evening Post*. But the details and the comic situations are often grace notes in
powerful compositions that address the nature of art and the vocabulary of
modernism, under the guise of inoffensive genre. Rockwell's penchant for narra-
tive clarity—his eye for the telling anecdote—is matched now by the aesthetic
ambition of his compositions.

"Frequently, after a monstrous struggle, thrash-
ing about, and noise. . . I find that the picture
isn't a picture, it won't go."
NORMAN ROCKWELL

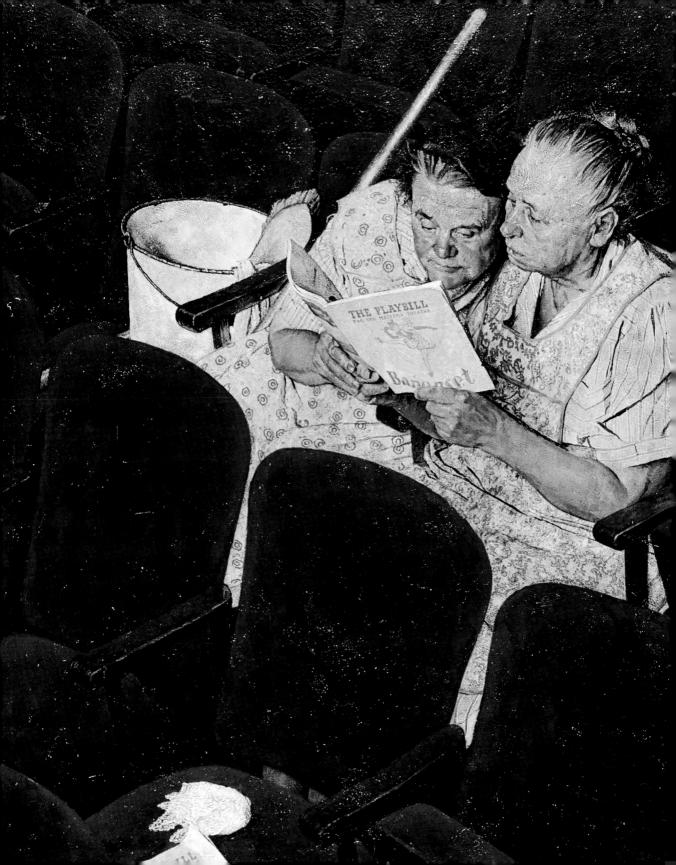

Postwar pleasures

At the end of World War II, America breathed a collective sigh of relief—and set about a decade-long celebration of the nation's own institutions, diversions, consumer products, novelties and behavioral quirks. After a decade of economic uncertainty and another of wartime fear and anxiety, Americans were ready to laugh with Norman Rockwell at their own fads and foibles, and to rejoice with him at their newfound prosperity. Family life assumed a deeper significance, now that families had been reunited. The landscape fairly hummed with building, rebuilding, traveling, and shopping, creating a comfortable lifestyle both in cities and in the mushroom suburbs springing up around them. America breathed a sigh of relief echoed in Rockwell's cover art of the late 1940s and the 1950s.

Many of his *Saturday Evening Post* covers of this era are elaborately anecdotal, stuffed and overstuffed with props that add to the authenticity of his scenes, but also convey a feeling that the meaning of postwar life was inextricably bound up with Pyrex coffeemakers, chrome toasters, and crisply ironed curtains. *Election Day* of 1948 (p. 58) is a case in point. The ostensible theme is the upcoming Presidential election, pitting the Republican candidate, Dewey (on his newspaper) against the incumbent Democrat, Harry Truman (on hers). But this is more than a battle of parties or sexes; it has thrown the whole household into turmoil. The baby is wailing. The dog and the cat are cowering. And the house is a magazine-perfect compilation of the latest in kitchen decor. Similarly, *Going and Coming* (p. 59), an almost cinematic double view of a family headed out for a holiday (on top) and returning home (on the bottom), tells its story as much through the props—the souvenir banner waving from the homebound car, the wet towels tied to the door handle—as the characters, who set off in the morning in a high state of excitement and return home again by night exhausted.

The Tired Salesgirl of 1947 (p. 60), slumped in a corner of the toy department on Christmas Eve, gains in credibility because of the litter of items scattered around her, in as much disorder as the shoeless young lady herself. Rag dolls, teddy bears, kiddie cars, tags, and stray sheets of wrapping paper account for her exhaustion: the stores are full of toys and shoppers again! The sign posted tipsily behind her head states that this store will close at 5 P.M. on Christmas Eve and, according to the watch pinned to her blouse, the hour is 5:05. If the reader takes the time to peruse the picture carefully, the story becomes clearer and more amusing.

Christmas Homecoming, 1948
Painting for *Saturday Evening Post* cover,
December 25, 1948
Oil on canvas, 90 x 85 cm
Stockbridge, MA, The Norman Rockwell Museum

ILLUSTRATION PAGE 56:
"Oh, Boy! It's Pop with a New Plymouth!," 1951
Ad for Plymouth cars, reproduced in *Saturday Evening Post*, December 22, 1951, p. 9

This ad ran in the Christmas issue, further confusing Rockwell the cover artist with Rockwell the ad man. In an era of growing prosperity, Santa Claus brings new cars in his pack instead of candy and rag dolls.

The same could be said of *Boy in a Dining Car*, the *Saturday Evening Post* cover for December 7, 1946 (p. 62). Young Peter Rockwell posed for the picture, in his winter clothes, in a stifling New York Central dining car parked on a siding outside the city in the August heat. The car was a real one, from the Lake Shore Limited, and the waiter, Jefferson Smith, was a real railroad waiter, too. Originally, at Rockwell's request, the railroad had dispatched a diner from the famous Twentieth-Century Limited to Albany for his use, but something in that first car did not match Rockwell's idea of what the scene should look like.

Eventually, he accumulated details from many sources—details ranging from the Central's distinctive menu and tablecloth to the china and the metal fittings that hold the table in place. But the subplot requires time and patient observation to read. The little boy, under the kindly gaze of the waiter, is trying to figure out how much to tip. The bill is turned toward the viewer. We could almost whisper a suitable number in his earnest little ear. And outside, the rather dismal industrial panorama of the urban fringe rolls by in shades of brown and gray. Peter Rockwell (who carries a *Felix the Cat* comic book in his pocket) remembered the hot day and the three hours of posing. It was worth it, though. He also remembered going into Manhattan afterward, to F.A.O. Schwartz, the famous toy store, and being rewarded for his work with a brand new truck.

The cover that best sums up the mood of Norman's postwar art is, perhaps, *Christmas Homecoming* (p. 57). All the Rockwells are there to welcome Jerry

Election Day, 1948
Saturday Evening Post cover, October 30, 1948
Indianapolis, IN, The Curtis Publishing Company

In the early postwar period, Rockwell's work dominated the prestigious covers of the *Post* because it mirrored the expansive mood of the country. The humorous domestic squabble over the upcoming presidential election is Freedom of Speech recast as an everyday reality.

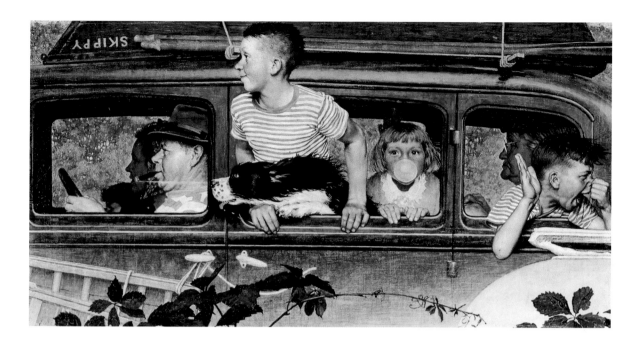

Going and Coming, 1947
Painting for *Saturday Evening Post* cover, August 30, 1947
Oil on canvas; each panel 40.5 x 80 cm
Stockbridge, MA, The Norman Rockwell Museum

The obsessive attention to detail—perfect knots holding the boat in place in the top picture
vs. frayed ropes in the bottom one—is only one of the elements that invites the reader to puzzle out the image
through inspecting pictorial clues. Note the happy faces and alert postures of *Going* in contrast
to the fatigue evident in *Coming*. Only Grandma remains unchanged.

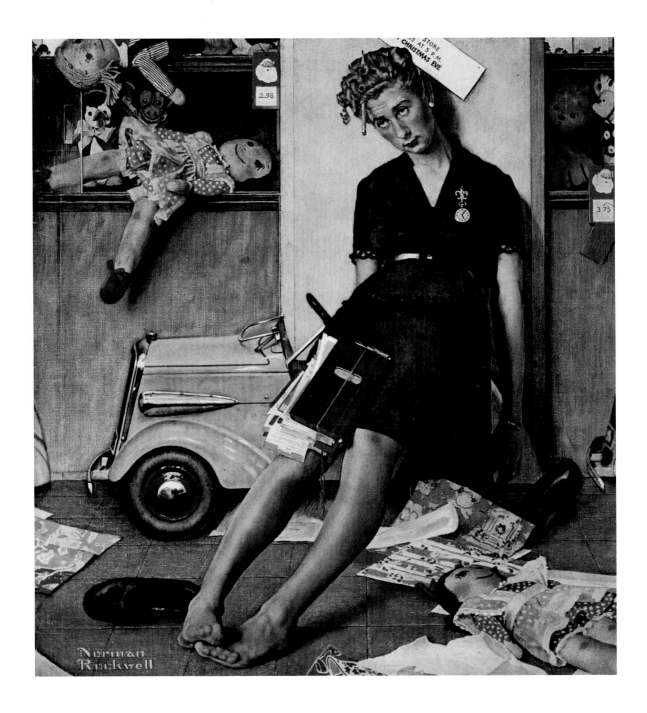

Tired Salesgirl on Christmas Eve, 1947
Saturday Evening Post cover, December 27, 1947
Stockbridge, MA, The Norman Rockwell Museum

Holiday covers were the illustrator's highest award. Now, Santa has been displaced by the
material abundance of America in the 1940s. And the heroic *Rosie the Riveter* (p. 40 bottom)
has gone back to work in a traditional, underpaid woman's job.

April Fool: Girl with Shopkeeper, 1948
Saturday Evening Post cover, April 3, 1948
Stockbridge, MA, The Norman Rockwell Museum

A bravura display of Rockwell's realism, this is also a
philosophical question: can the artist "lie" even while
depicting objects of startling verisimilitude? Was his cheerful art a lie?

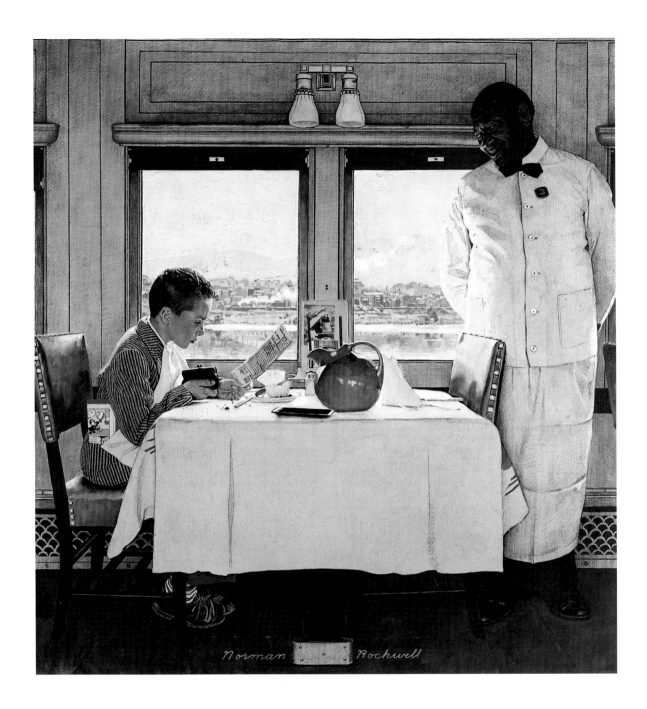

Boy in a Dining Car, 1946
Painting for *Saturday Evening Post* cover, December 7, 1946
Oil on canvas, 96.5 x 91.5 cm
Stockbridge, MA, The Norman Rockwell Museum

The ability to travel freely was another bonus of peace.
But as the Civil Rights Movement began to take shape, the *Post's* editors
apparently preferred that African-Americans be depicted as servants.

home from school: his mother Mary, hugging him joyfully; his brothers Tommy, in the plaid shirt, and Peter, in glasses, at the far left; and Norman Rockwell, with his pipe and bow tie, looking on with pleasure. Half of Arlington is waiting by the Christmas tree—Athertons, Schaeffers, and little Sharon O'Neil, the doctor's daughter, who was so cute that Norman made her into twin girls. And Grandma Moses, the elderly, self-taught "primitive" painter from a nearby town who was making a huge splash in the New York art world which still largely ignored her friend Norman.

The faces, the presents, the bulging suitcase, the patterns and colors of the clothes all combine to fill the field of vision to bursting point, as though the joys of American life could scarcely be contained in a single image. The increasing plenitude and exactness of his realism raised questions in Rockwell's mind, however. In 1943, prodded by letters to the editor that accused him of various "mistakes" in his pictures, Rockwell began a series of April Fool's Day covers, deliberately filled with such errors. *April Fool: Girl with Shopkeeper,* the 1948 version of the joke (p. 61), uses an antique shop as the excuse for a space crowded with objects of all kinds: dolls, statuary, books, old clocks. And just about every item is strange. The shopkeeper's writing instrument is a pencil at one end, a fountain pen at the other. His customer wears two different shoes, and carries a school book as a purse. Rockwell counted 57 mistakes and challenged the *Post's* readers to find them all.

The result is not the Great American Puzzle but a kind of overwrought examination of what realism really is. The contents of the store look incredibly real, thanks to Rockwell's technique. Yet it is all an illusion. The little dog has the body and tail of a raccoon. Huge birds flap through the store, all unnoticed. The little girl is shown three times—as a customer, a statue, and a tiny live girl, seated on a shelf, cuddling a skunk. The "Mona Lisa," wearing a halo, turns the wrong way. Abe Lincoln wears U. S. Grant's uniform. Even Rockwell's own name is spelled wrongly.

The dilemma of the picture says something about Rockwell's dilemma as a commercial artist. His job demanded cute, sweet, funny vignettes from daily life, yet his technique had reached a polished sophistication that often seems wasted on his subject matter. *April Fool* breathes a mystery, a disturbing, Surreal half-awareness that something is not quite right with Rockwell or with the culture of satiety in which he works.

The new America is chockfull of TV sets, new cars, the privileged children of the Baby Boom, organized sports, and ranch-style houses. America is on the move, always going somewhere, impelled by a restless urge to move to the suburbs. It bustles. It speeds by so quickly that it is hard to comprehend in a single picture. It almost explodes with energy. *Happy Skiers on a Train* (p. 63), like the train Rockwell often rode back to Vermont in the winter, is stuffed with sweaters (Norman bought the two most colorful ones), ski poles, and merrymakers pushing and joking. *New Television Antenna* (p. 65) describes the button-popping excitement in an old city neighborhood when modernity, in the form of a TV antenna, finally arrives. *Roadblock* (p. 64 left) shows a moving van crammed into an urban alley like a cork in a champagne bottle, threatening to pop out at any minute. In the building on the left, a painter and his model watch the excitement with extravagant gestures; everyone in the picture is alive with the nervous energy of the occasion.

The moving van and the TV paintings were both done in Los Angeles, where the Rockwells sometimes turned up during long Vermont winters. The energy is

Happy Skiers on a Train, 1948
Saturday Evening Post cover, January 24, 1948
Stockbridge, MA, The Norman Rockwell Museum

Rockwell often came back from appointments with city art directors on a train like this one, full of vacationers. This is his story, yet the mild joke is all but buried by the pyrotechnics of a daring composition and a bravura use of pattern and texture. It is a painting masquerading as another funny magazine cover.

ILLUSTRATION LEFT:
Roadblock, 1949
Saturday Evening Post cover, July 9, 1949
Stockbridge, MA, The Norman Rockwell
Museum

The tiny dog holds up the huge van: that's the
joke. The real subject is the bursting energy of
the postwar urban scene.

ILLUSTRATION RIGHT:
Game Called Because of Rain, 1949
Saturday Evening Post cover, April 23, 1949
Indianapolis, IN, The Curtis Publishing
Company

The "national pastime" is back in full force with
this game between the Brooklyn Dodgers and
the Pittsburgh Pirates. Real ball players were
pleased to pose for a Norman Rockwell cover.
The umpires are pondering whether to cancel
the game at the top of the sixth inning—before
the score becomes official. In that case, the
Pirates would not get their win.

at least partly that of the American West, the most progressive place in the country, the new land where the dreams glimpsed on the movie screen could readily come true. The models who posed in the alley were, for the most part, students and teachers from the Los Angeles County Art Institute. The house with the antenna was in the Adams Street neighborhood of L.A. But whether the scene was set in California, New York, Vermont, or some nameless town in Rockwell-land, the aesthetic energy that marks the ads and the cover paintings of the 1940s and 50s is the most compelling as well as the most disturbing quality of Norman's postwar art.

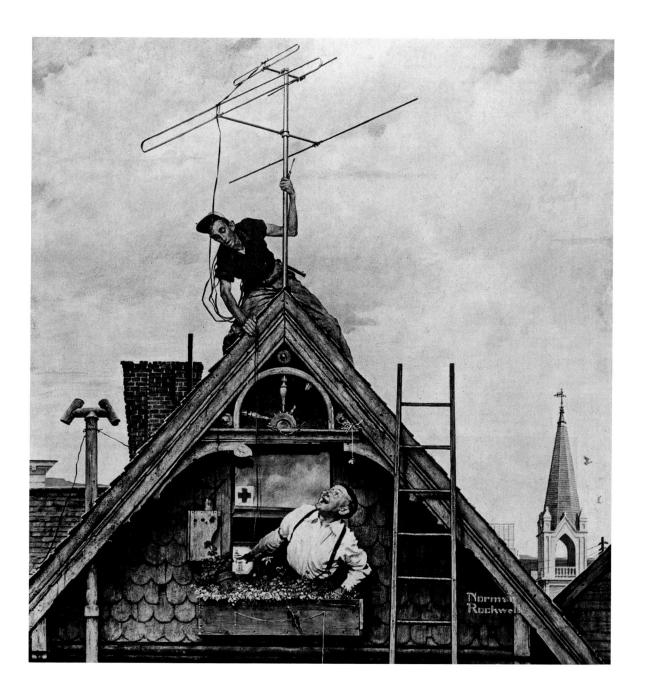

New Television Antenna, 1949
Saturday Evening Post cover, November 5, 1949
Stockbridge, MA, The Norman Rockwell Museum

The old house, with its gingerbread trim, and the church steeple in the background
both hint at the serious cultural displacement in progress. Modernity triumphs over the past;
the TV sitcom will be more important than the old verities of religion.

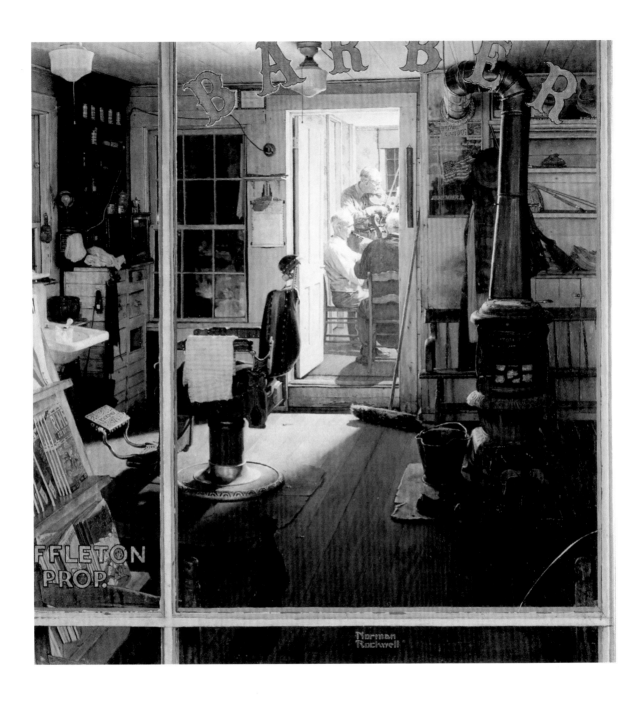

Cute kids, again

The period of Norman Rockwell's greatest success—the forties and fifties—was also among the most difficult of his life. He worked and overworked incessantly: expenses were high, with his sons to educate and other family members in need. The fate of the *Post* was on his mind. His wife Mary had developed a variety of problems, including alcoholism. And Norman himself was hit by black bouts of depression.

After months of arduous commuting from Arlington to Stockbridge, Massachusetts, where Mary was undergoing a promising course of treatment at the Austen Riggs sanatorium, the Rockwells finally pulled up stakes in 1953 and moved to Stockbridge for good. Norman sought out counseling with Erik Erickson and others of the world-class staff at Riggs as he struggled to paint enough to meet the financial burden of this abrupt life change. In 1959, Mary Rockwell died unexpectedly of heart failure. But it would be hard to guess from looking at most of his work during this volatile interlude that anything might be wrong with Norman or the world around him.

Instead of sharing his troubles in pictorial form, Norman fell back upon the tried and true subject matter of his youth: boys and girls engaged in acts of charming cuteness, innocent pictures far removed from the trials of the Cold War and the personal upheaval confronting him at home. Ironically, it is on these works that his popular reputation rests, even today—a bright, happy world of well-scrubbed, adorable children making their way through life with a combination of high energy, a daunting sweetness, and a willingness to trust (most of the time) in the benevolence of the adults around them. Big Boy Scouts help little ones; scoutmasters are watchful and trustworthy. Teenagers are not the crazed, sex-mad stereotypes of Hollywood movies but solemn, responsible adults-in-training.

Rockwell's compositions occasionally flash with his old brilliance. It is apparent, however, that the *Saturday Evening Post* no longer fulfilled his highest ambitions. There were serious problems with the *Post's* management, too. Ken Stuart, the current art director, had begun to turn down Norman's ideas in favor of his own notions of the perfect Rockwell cover. Increasingly, Stuart demanded changes in finished canvases. The new preeminence of the photo magazine—*Life* is the prime example—meant that illustrators were no longer crucial to the success of a cover, especially if, like Rockwell, they had been allowed to pick their

Practice, 1950
Saturday Evening Post cover, November 18, 1950
Stockbridge, MA, The Norman Rockwell Museum

The chubby boy and the overstuffed chair were made for each other. The slipcover comes from a new, postwar line of fabrics using the designs of "famous artists" as inspiration.

ILLUSTRATION PAGE 66:
Shuffleton's Barbershop, 1950
Painting for *Saturday Evening Post* cover, April 29, 1950
Oil on canvas, 117.5 x 109 cm
Pittsfield, MA, The Berkshire Museum

The masterful use of illusionistic space and nighttime illumination goes far beyond the demands of cover illustration. Nor does the image seem to answer the practical demand for a cover that can tempt a potential reader from a distance.

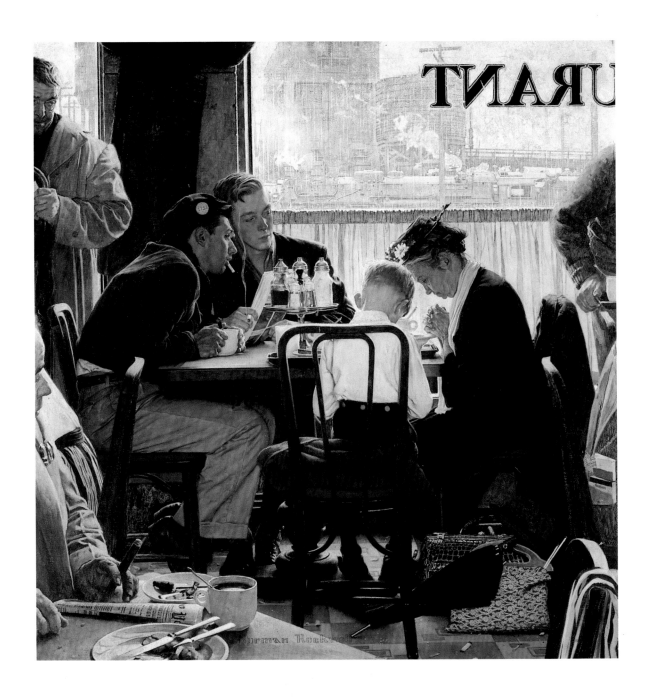

Saying Grace, 1951
Painting for *Saturday Evening Post* cover, November 24, 1951
Oil on canvas, 106.5 x 104 cm
Private collection

The idea for the picture came from Norman's fan mail;
by 1951, Americans could look at a given scene and
realize that it was a "Rockwell" moment.

own subjects freely, regardless of a given journal's editorial policy or assessment of the preferences of its readership.

In the fall of 1949, believing that he knew better than Norman the mind of the *Post* buyer, Stuart actually had a section of a cover painting repainted without telling the artist that he had done so. The reasons for the censorship are muddy: originally, the staff seems to have believed that the perspective could make it appear that a young cowboy and his girlfriend were dressing for a date in the same room. Potentially, then, the picture was immoral. But the change, as x-ray analysis has demonstrated, was made elsewhere. Stuart engineered the removal of the boy's horse observing his master through an open window, for no discernible reason of taste or propriety.

Rockwell later glossed over the incident in his autobiography. At the time, nonetheless, he was cut to the quick and, in a letter to editor Ben Hibbs and to Stuart, threatened to do no more covers for the *Saturday Evening Post* if he was to be treated as just another hired paintbrush or an irksome means of mechanical reproduction. In time, with coaxing from Hibbs, the crisis passed. Yet nothing would ever be quite the same between Norman Rockwell and the

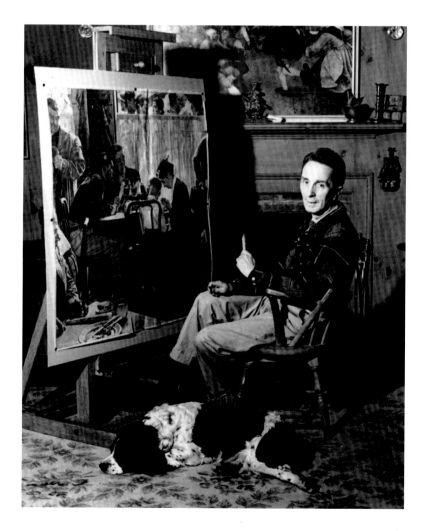

Norman Rockwell in his Vermont studio, 1951

Saturday Evening Post. The incident only added to the troubles that now plagued him.

There were two bright spots in the darkness of the early 1950s. The first was a *Post* cover that modern critics widely regard as Rockwell's masterpiece: *Shuffleton's Barbershop* (p. 66). The setting is an old corner barbershop in East Arlington, soon to be displaced by a grocery chain's newest outlet. After hours, a group of old men has come together to make music, observed only by a watchful cat and by us, the lucky passersby peering through the shop window into the brilliantly illuminated back room. There can be no doubt about the authenticity of the place. Every square inch of the picture, from the magazine covers and comics in the rack near the window to the leftover World War II poster on the wall and the fisherman's creel stowed on a shelf, has been studied and rendered to perfection.

The effect is a kind of "Magic Realism." In viewing a scene like this one, the focus of the eye is selective, picking out one object after another and blurring the rest. But in Rockwell's barbershop, no such limitations pertain. Everything is present at the same degree of intensity, at the same time. The effect is to enhance the viewer's physical powers of vision—to make him or her omniscient.

The space is as complicated as any Velazquez rendering of the Spanish royal family. There is the plate glass window that bears the owner's name, a crack in

ILLUSTRATION PAGE 70:
The Scoutmaster, 1956
Painting for 1956 Boy Scouts of America calendar
Oil on canvas, 117 x 84 cm
Washington, DC, National Office, Boy Scouts of America

The protective Scout leader, watching over his charges by night, radiates a mood of sadness. Perhaps the Scoutmaster wishes he could be a carefree, trusting little scout again.

ILLUSTRATION PAGE 71:
Our Heritage, 1950
Painting for 1950 Boy Scouts of America calendar; *Boys' Life* cover, February 1950
Oil on canvas, 106.5 x 81 cm
Washington, DC, National Office, Boy Scouts of America

This is a convention Rockwell had used frequently in his early career: a vision that allows the audience to understand what the subject is thinking. The background picture of George Washington praying in the snows of Valley Forge (soon to be a postage stamp) was painted by illustrator Arnold Friberg.

The Saturday Evening

POST

March 15, 1958 — 15¢

I SHOOT THE BIG SHOTS

By a White House Photographer

..

We Couldn't Pay Our Bills

By an Installment-Plan Slave

Before the Shot, 1958
Saturday Evening Post cover, March 15, 1958
Stockbridge, MA, The Norman Rockwell Museum

This is another in the series of cute but innocuous covers Rockwell did for the *Post*
shortly before he left that publication, angered by unauthorized changes to his work,
restrictions on his themes, and the yawning gap between the *Post's* world and growing unrest
in the streets, as the Civil Rights Movement gathered strength.

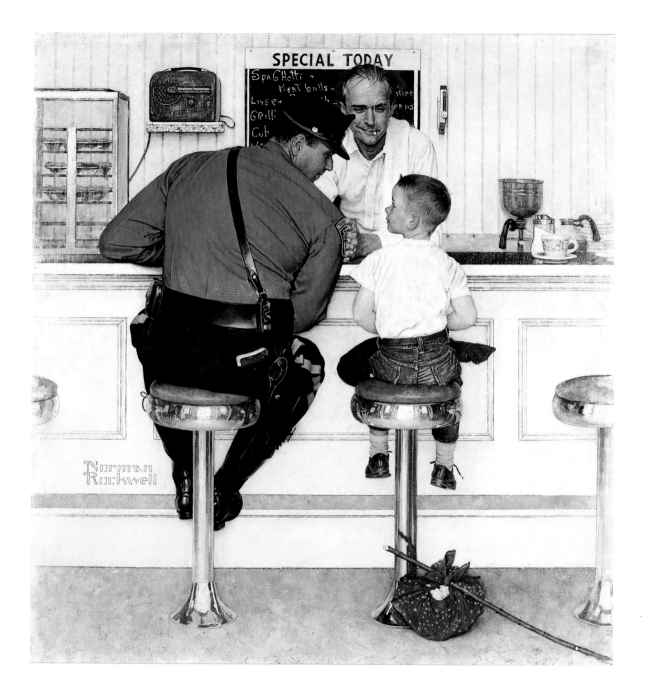

The Runaway, 1958
Painting for *Saturday Evening Post* cover, September 20, 1958
Oil on canvas, 91 x 90 cm
Stockbridge, MA, The Norman Rockwell Museum

Despite the vast sophistication of Rockwell's best work for the *Post*, his sweet,
innocent, occasionally "bad" children came to define his art in the public mind during the 1950s.
In the face of real national issues and problems, the biggest crisis in his world seems
to come when a runaway meets a friendly cop.

First Formal, 1953
Ad for Massachusetts Mutual Life Insurance
Co., reproduced in *Saturday Evening Post*, July
18, 1953
Pencil on paper, 28.5 x 16 cm
Stockbridge, MA, The Norman Rockwell
Museum

The crisp black-and-white drawings sharpen
the meaning of this series of 81 works, extending
over a ten-year period. The ads describe mo-
ments in family life with real solemnity and
dignity.

one corner of the glass, and Norman's signature: that glass and the picture sur-
face are one and the same, as in classical Renaissance illusionism, in which a
scene materializes in depth behind a fictional sheet of glass. But identical win-
dows also define the space of the shop on the side and back walls to the left and
a similar rectangular opening frames the door into the back room, through
which another door and window are also visible. The interior is intricately fitted
together like a series of nesting boxes or mirrors arranged to reflect one another
endlessly.

Light also plays a major role in the revelation of the space. Intense and warm
in the back room, it spills out into the shop to lead the eye toward the musicians.
Rockwell told a friend that when he was working on the picture over a two or
three month period in 1949, the weather was cloudy and the light diffused,
whereas his conception called for a sharp illumination, albeit from a hidden
source, in the players' space. So he fretted and worried, and remembered
Vermeer of Delft and his rays of benevolent light penetrating the darkness of
little rooms.

Like Vermeer and any number of 19th-century American genre painters who
employed musical themes, the challenge here seems to be to hear the music pro-
voked by the visual atmosphere in which it is being created. Are they practicing
for a summer band concert? Trying out some classical exercise? Whatever the
tune, they are making art in a commercial setting which, of course, is exactly
what Norman Rockwell was struggling to accomplish. In a world of kitty-cats
and comics and cast-off rubber boots, in an ordinary American town on a cold
dark night, it is still possible to make great art.

Saying Grace (p. 68), the Thanksgiving cover for 1951, was the most popular
cover the *Post* ever printed, judging by the volume of requests for copies. Again,
it is a study of light and space disguised as a pious anecdote. The idea was sug-
gested by a reader's letter to Rockwell, describing something she had recently
witnessed in a Philadelphia branch of the Horn & Hardart cafeteria chain. There,
she said, she had seen an old Mennonite woman and her grandson saying grace
before their humble meal.

Norman began, as usual, by assembling his props: an H & H condiment tray,
the thick restaurant china, the umbrellas. The grandson: Norman's eldest son,
Jarvis (Jerry). The mesmerized onlookers: his photographer, a local derelict, a
brace of teenagers. Chairs were shipped to Arlington from a New York automat.
Details were studied firsthand at the Juniper Street H & H in Philadelphia. The
scene in the steamy window vacillated between a view of a flower garden, of
pedestrians passing on the sidewalk, of a railroad yard in an industrial district.

The chosen scenery seems to have dictated the humid, bleak light that dimly
illuminates the interior. As for the window itself, it forms a secular halo around
the heads of the praying travelers, almost by accident. The centerpiece of the
composition—the spot toward which the viewer's attention is directed—is fur-
ther defined by tiny touches of bright red, arranged in a circular pattern: the
chair seats, the cruet, the flower on her hat, the feather in the little boy's hat
band. The result is a traditional religious painting couched in the language of
genre, a *sacra conversazione* set in the bowels of Philly in the middle of the 20th
century.

The complexity and high seriousness of these pictures describe a Rockwell
chafing under the restrictions of the *Post's* expectations and struggling to carve
out a new niche for himself as a painter of significant subject matter, of themes
destined to outlast the flimsy cover of this week's 15-cent magazine. Most of his

Girl at the Mirror, 1954
Painting for *Saturday Evening Post* cover, March 6, 1954
Oil on canvas, 80 x 75 cm
Stockbridge, MA, The Norman Rockwell Museum

One of Norman Rockwell's most penetrating psychological studies, this picture captures a moment of
self-doubt on the part of a girl becoming a woman. Will she be as pretty as the movie star—Jane Russell—whose picture
she holds? Her doll has been cast aside in favor of face powder, lipstick, and a comb.
These are private doubts, but the mirror allows us to share them.

remaining *Post* commissions of the 1950s seem perfunctory, as if Norman, having once tasted success with entirely different work, sent in his annual quota of cute kids almost by reflex. While the drawing is often sharp and lively, especially in sketches prepared in pencil and watercolor, these covers are memorable chiefly for their heavy doses of sentimentality.

There are exceptions to the rule. *Girl at the Mirror* (p. 75) is a genuinely heartbreaking depiction of the anxieties of girlhood, and Rockwell's ten-year series of ads (p. 74) for the Massachusetts Mutual Life Insurance Co., begun in the early 1950s, were presented as casual black-and-white drawings executed with a freshness and enthusiasm sometimes missing from the highly polished *Post* covers. His art, then, especially his canvases for the *Saturday Evening Post*, describes a frustrated man, capable of great work, but increasingly stifled by the demands of the commercial milieu in which he had excelled for so long.

The Gossips, 1948
Painting for *Saturday Evening Post* cover,
March 6, 1948
Oil on canvas, 84 x 79 cm
Private collection

Making fun of an all-American pastime, Rockwell used his Vermont neighbors to create the keyhole portraits of the pungent individuals spreading a story. Then, he added himself and his wife Mary to take the sting out of his commentary. The *Post* questioned whether these were real people, until Norman showed them the photographs he had taken of each one (p. 2).

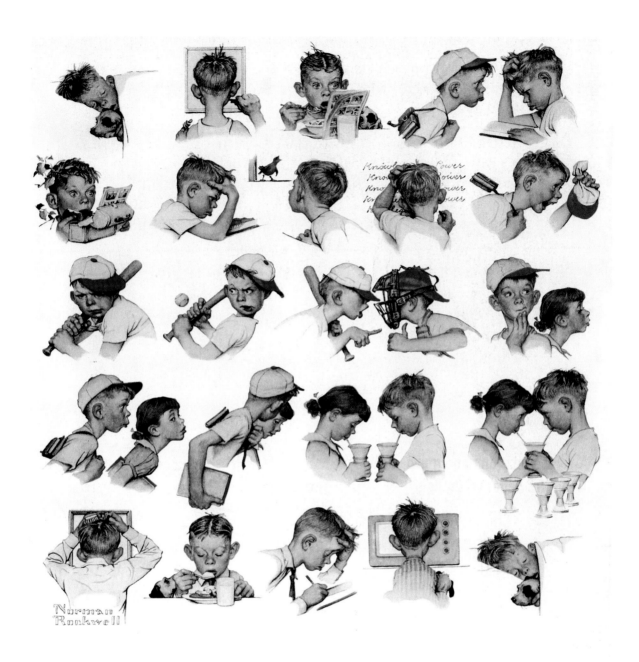

A Day in the Life of a Little Boy, 1952
Saturday Evening Post cover, May 24, 1952
Stockbridge, MA, The Norman Rockwell Museum

In this work and a companion study of a little girl, Rockwell uses a crisp notational style based
on pencil drawings and watercolor, anticipating his later ads for Massachusetts Mutual Insurance (p. 74).
This little fellow does everything Rockwell's boys of the 1920s and 30s did—and more.

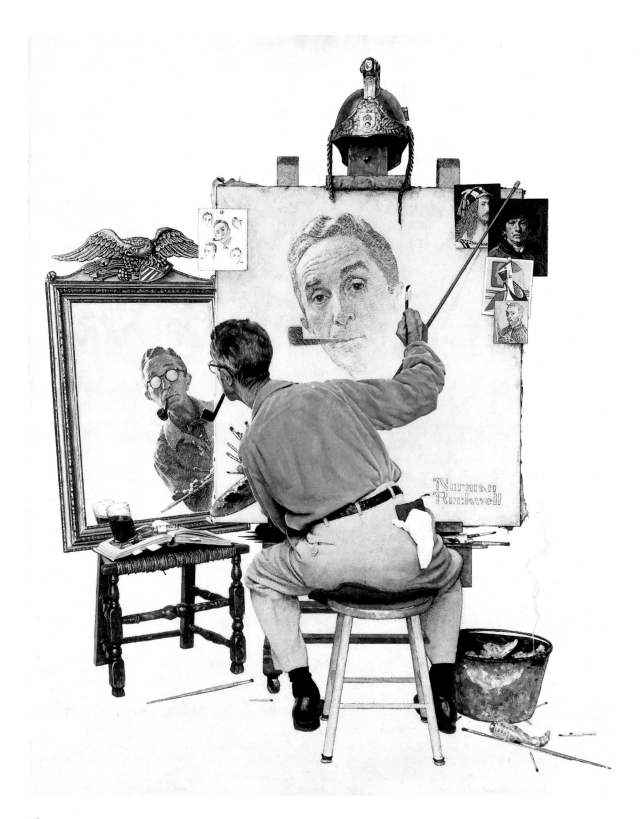

Norman Rockwell paints his "Big" pictures at last

In 1957, Norman and Mary completed the move to Stockbridge by purchasing a home and converting the old carriage house behind it into a studio; in the interim, he had been working out of a rented space above Sullivan's Meat Market on Main Street. From that date until his death in 1978, Rockwell enjoyed some of his happiest and most productive years, although the topical, sometimes controversial work of this period has not, until recently, enjoyed the spectacular popularity of his earlier exercises in sentimental nostalgia. A good example of the new seriousness and self-confidence in Norman's art came in 1960, when the *Post*, acknowledging his importance to the magazine, published a serial version of his autobiography (as told to son Tom), later released in book form under the low-key title, *My Adventures as an Illustrator*. To accompany the text, Rockwell completed a complex and revelatory cover, the so-called *Triple Self-Portrait* (p. 78).

On many occasions in the past, Norman had used the figure of an earnest craftsman seen from the rear—a tattooist (p. 41), a sign painter (pp. 22–23)—to poke gentle fun at the pretenses of the fine arts. And this picture is not without its self-deprecating humor. Rockwell's ample bottom is emphasized by the red of the cushion on which he sits; as was too often true in reality, he has managed to set a bucket of rags afire with the ashes from his omnipresent pipe. The gloriously theatrical Roman helmet atop the easel (and thus crowning the self-portrait in progress) is another admission that this humble illustrator may be playing a well-rehearsed part—that of an "artiste"—in his own picture.

The "artiste" is peering into a mirror, in which we see his face, blurred and softened somewhat by reflection. Although he appears to be painting the man in the mirror, the canvas on the easel shows a much younger Rockwell, without the glasses, fuller of face and candid in his appraisal of the onlooker. But the eyes of the Norman-in-the-mirror are not visible, thanks to the glare on the lenses of his spectacles. Art, then, even the descriptive art of portraiture, is a fiction, a construct, a creation. It is not a simple matter of camera-like verisimilitude. Rockwell essentially hides the truth behind veils of fiction. He reshapes himself in the light of memory, much as he does in his unfailingly cheerful reminiscences in the *Saturday Evening Post*. Or he incorporates his past (the fellow on the easel) and his future (the evanescent blur in the mirror) into the present—February 13, 1960—as the *Post's* star positions himself, hard at work, squarely in the center of the cover.

The Peace Corps, 1966
Illustration for *Look*, June 14, 1966, p. 35
Oil on canvas, 115.5 x 92.5 cm
Stockbridge, MA, The Norman Rockwell Museum

ILLUSTRATION PAGE 78:
Triple Self-Portrait, 1960
Painting for *Saturday Evening Post* cover, February 13, 1960
Oil on canvas, 113.5 x 87.5 cm
Stockbridge, MA, The Norman Rockwell Museum

By presenting himself as a collection of images —past, present, and future—Norman unfolds his own biography in paint. On the inside of the same issue of the magazine, his written autobiography was serialized.

Rockwell painting his own "Pollock," 1961

Throughout his career, Rockwell had created works that explored
the art and the craft of painting. In this final work in the series, he also declares
himself open to the new aesthetic of postwar art: Abstract Expressionism.

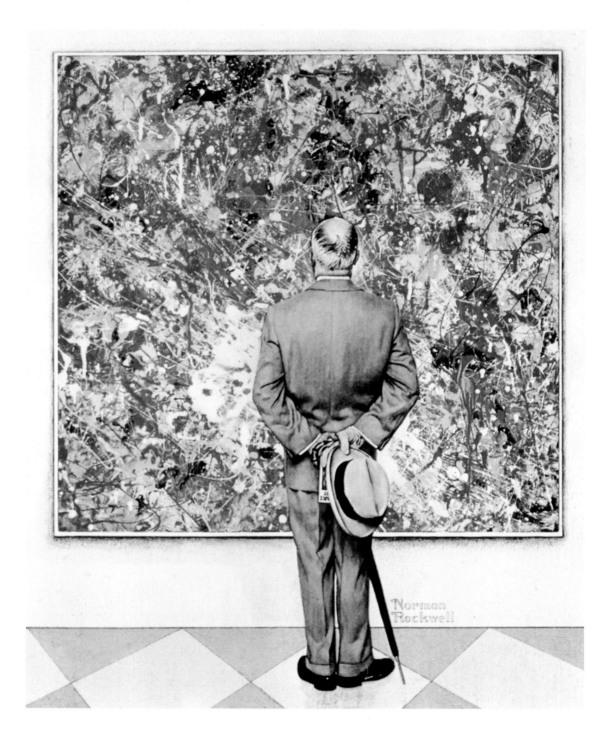

The Connoisseur, 1962
Saturday Evening Post cover, January 13, 1962
Indianapolis, IN, The Curtis Publishing Company

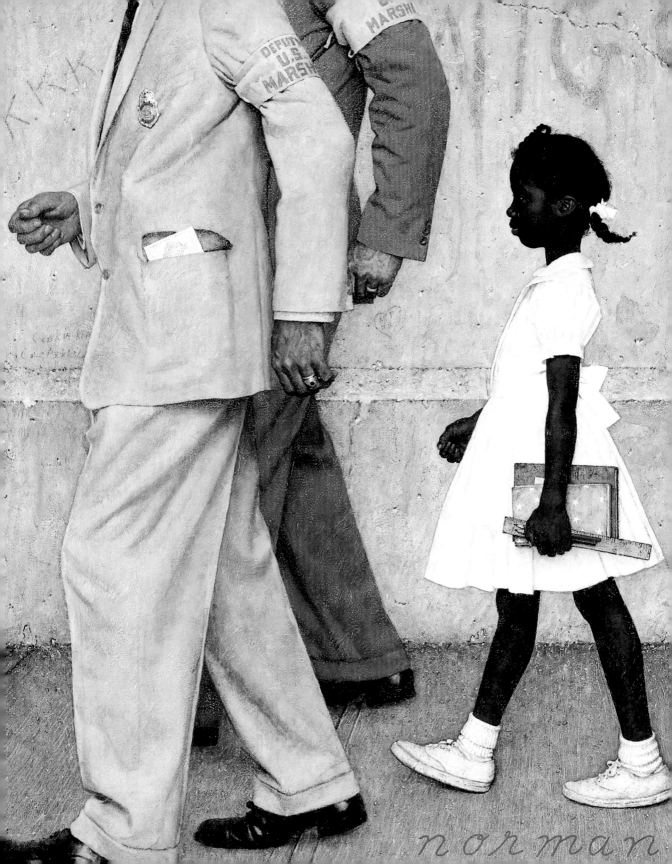

rockwell

"I get up every morning. I'm at work by eight. I
no longer believe that I'll bring back the golden
age of illustration. I realized a long time ago that
I'll never be as good as Rembrandt."
NORMAN ROCKWELL

There is more at stake here than Norman's meditation on resemblance and
non-resemblance, however. The postcards and reproductions tacked to the upper
right corner of his canvas also help to position Rockwell among the greats of the
art world: Durer, Rembrandt, Picasso, and Van Gogh, artists he deeply admired,
shown in self-portraits. Without a hint of false modesty, Rockwell lays claim to a
place in that company, in the glorious continuum of Western art.

Interviewers always asked Rockwell about contemporary art, as if anticipating
that such an old-fashioned, paint-a-picture sort of personality would dismiss
"modern art" as an abomination. Much to their surprise, however, he always
showed a lively interest in and admiration for the moderns, from Picasso to
Pollock. *The Connoisseur* (p. 81) is an amusing study of a sober citizen in a gray
business suit virtually consumed by a riotously colored "drip" painting in a mu-
seum. To paint this picture of a painting, Rockwell (with the help of a local house
painter) actually made his own pseudo-Jackson Pollocks and commemorated the
event in a series of photographs (p. 80). In Stockbridge, surprisingly, Rockwell also
took painting classes along with a flock of local amateurs, in an effort to try out
looser styles than his own technique, evolved a half-century earlier, would permit.

But it is clear that, as his association with the *Saturday Evening Post* loosened,
he rediscovered his ambition to paint "big" pictures. In the afterglow of *Shuffleton's
Barbershop* (p. 66) and *Saying Grace* (p. 68) it is hard to imagine any greater
artistic achievements. Yet Rockwell seems to have associated "big" pictures with
a kind of public statement of universal significance. *The Golden Rule* of 1961
(p. 85), for instance, reverts to the spirit of the Four Freedoms series, and partic-
ularly, to *Freedom to Worship* (p. 39). Many of the portrait heads are taken from
that canvas and from earlier studies of his Arlington neighbors. Likewise, in lieu
of pictorial storytelling, the meaning of the work is conveyed by the text, embla-
zoned across the surface in gilded letters. The artistic results are not impressive,
but the inclusivity of the assembled representatives of the world's religions is.
Africans and African-Americans are especially prominent as if, after years of
following tacit editorial taboos against depicting people of color, Rockwell had
decided to follow his own conscience in the matter of integrating a *Post* cover.

After Mary's death, Rockwell had remarried in 1961. During the early 60s,
he continued to spend time with a coterie of local Stockbridge intellectuals and
activists, many of whom were associated with the Riggs clinic. He formed close
friendships with both Erik Erickson and Robert Coles, psychiatrists specializing
in the treatment of children and passionate advocates of civil rights. Norman's
interest in both these subjects, and the *Post's* tacit refusal to admit that all was
not right with America, led him to sever his connections with the financially
troubled magazine after an association of almost half a century. On December
14, 1963, a portrait of the late President John F. Kennedy became his last *Post*
cover. In 1964, he became signed on with *Look* magazine as a specialist in current
affairs.

Rockwell's first double-page illustration for *Look* is one of his most memo-
rable paintings (pp. 82–83). By virtue of its principal character—a perky little
black girl in an immaculate white dress—it was an overt challenge to his reputa-
tion as a purveyor of sweetness and light. While the child, at first glance, could be
one of his patented cuties, the work undercuts such expectations by the graffiti
and the splattered tomatoes on the wall behind her and the U. S. marshals who
hem her in on either side. She represents Ruby Bridges, the courageous little girl
who made an inroad into the whites-only New Orleans school system in 1960 by
attending every day in the face of violent racist opposition.

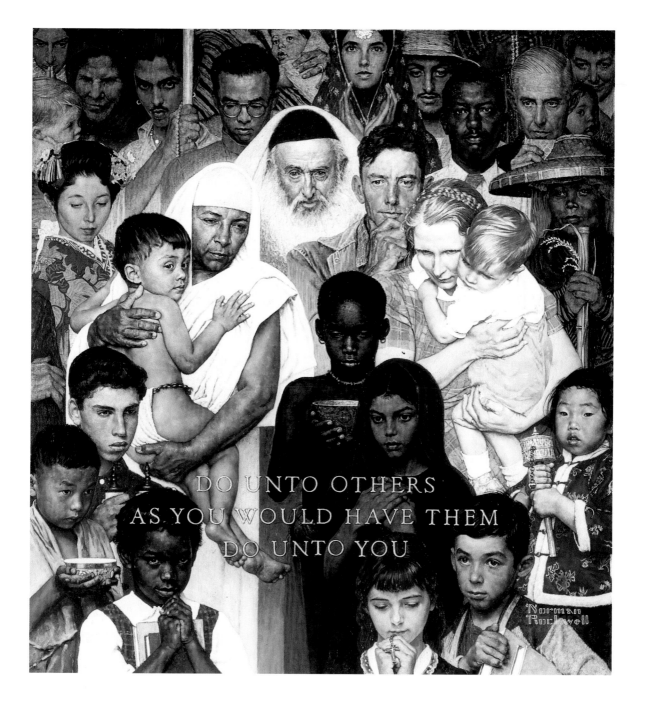

DO UNTO OTHERS
AS YOU WOULD HAVE THEM
DO UNTO YOU

The Golden Rule, 1961
Painting for *Saturday Evening Post* cover, April 1, 1961
Oil on canvas, 113.5 x 100.5 cm
Stockbridge, MA, The Norman Rockwell Museum

In his quest for a significant artistic statement, Norman returned to his
World War II depictions of the Four Freedoms. Many of the same residents of
Arlington, Vermont, who posed for the earlier series reappear here.

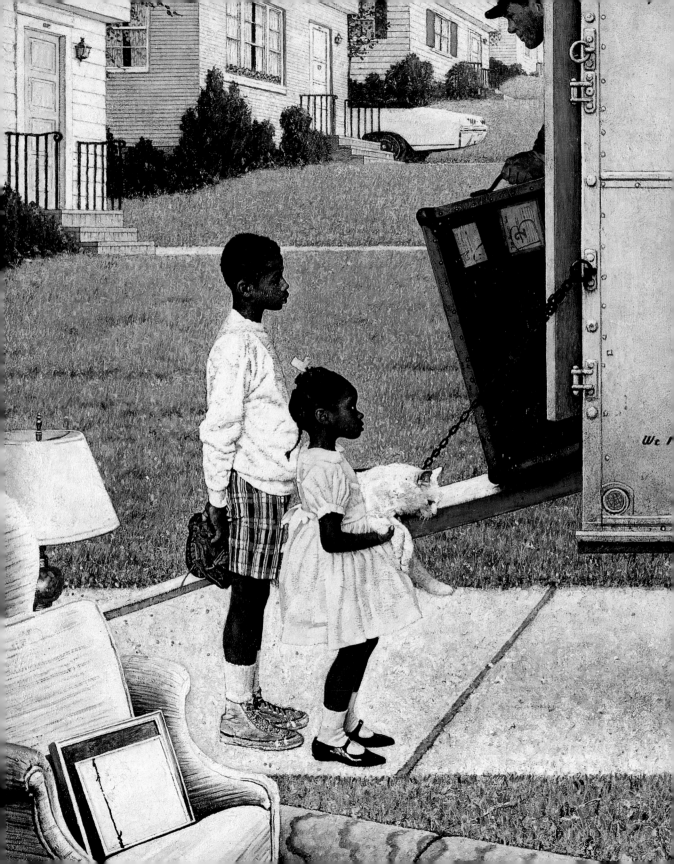

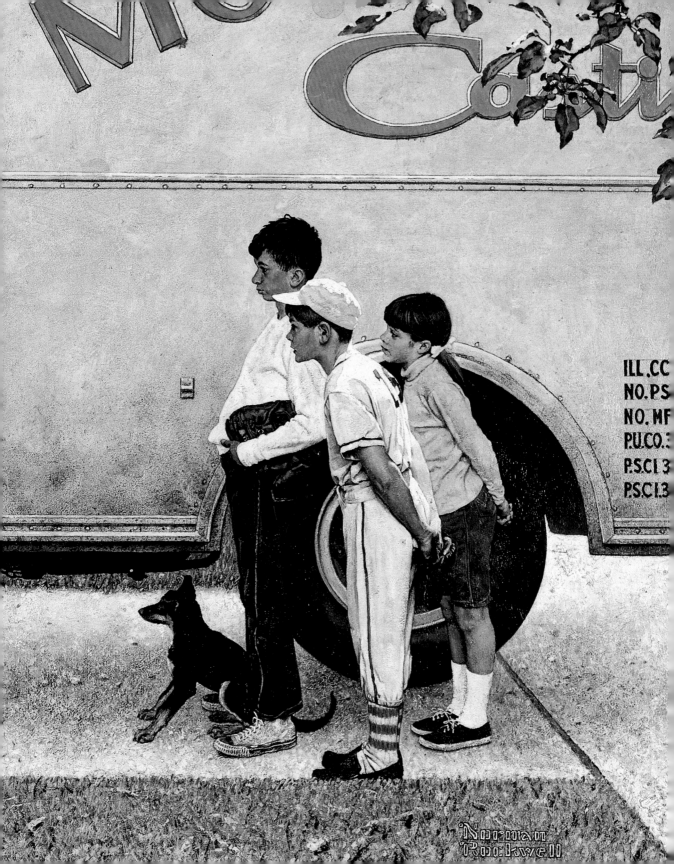

Her story was well known in 1964. Robert Coles had written a study of her drawings, showing the effects of segregation on African-American youngsters. John Steinbeck, in his best-selling *Travels with Charlie*, reported the cruel and hateful epithets that greeted Ruby every day, as her federal guards escorted her to school through hostile crowds. By making Ruby small and her guardians large, Rockwell increased the drama of her plight; her white clothes define her as an innocent confronting the evil of American racial prejudice. *The Problem We All Live With* (pp. 82–83) disclosed a "new," 70-year-old Norman Rockwell, an activist who used the most appealing qualities of his former work to crusade for social justice.

Rockwell's idealism was echoed by that of John F. Kennedy and the stirring challenge to the nation offered by Kennedy's 1960 presidential campaign. During 1964, many of the problems and ideals addressed by the young president had already been tackled. The Civil Rights Act was signed into law. An American spacecraft had sent back the first clear photographs of the lunar surface. And during convention season, as if to remind his fellow citizens of the opportunities and obstacles still ahead, Rockwell reconstructed the Democratic Party convention of 1960 in a *Look* illustration entitled *A Time for Greatness* (p. 91). That phrase came from a Kennedy campaign slogan visible on the placards carried by the delegates in the painting. This time, instead of staging an event and taking a picture of it, Norman worked from press photographs of the event, as a documentarist or history painter, using his art to challenge his audience to rekindle the spirit of the recent past.

Negro in the Suburbs (p. 86–87) illustrated a story on the progress of racial integration published by *Look* in 1967. The report examined what would later be called "white flight," or an exodus to suburbia motivated by prejudice and urban unrest. Were middle-class blacks welcome in the suburbs? Norman Rockwell clearly thought they should be in his low-key look at a group of youngsters inspecting newcomers all but identical to themselves in dress and deportment. The one difference is race. The new arrivals are African-Americans (and own a cat). The neighborhood kids are Caucasian (and have a dog). Again, Rockwell reverts to familiar characters to make a political or moral statement in language well known to his admirers.

Some Americans turned a blind eye to Rockwell's pleas for racial justice and idealism, however. In the summer of 1964, three so-called Freedom Riders—James Chaney, Michael Schwerner, and Andrew Goodman—were killed for their

Southern Justice, 1965
Color study for *Look*, June 29, 1965
Oil on board, 40.5 x 32.5 cm
Stockbridge, MA, The Norman Rockwell Museum

ILLUSTRATION PAGE 89:
Southern Justice, 1965
Unpublished illustration for *Look*, June 29, 1965
Oil on canvas, 134.5 x 106.5 cm
Stockbridge, MA, The Norman Rockwell Museum

Based on the highly publicized fate of three Civil Rights workers killed for their efforts to register African-American voters, this powerful picture gains force through the realism of the treatment: the viewer is there, an eyewitness to horror. *Look* published the unfinished sketch for the picture, however, preferring its raw emotion (p. 88 top).

Blood Brothers, c. 1968
Study for lost painting, once in the collection of C.O.R.E.
Oil on board, 54.5 x 26.6 cm
Stockbridge, MA, The Norman Rockwell Museum

Other studies depict the two young men in the uniform of the Marine Corps. The work is a statement of Rockwell's belief in the fundamental equality of people, as well as a protest against the Vietnam War.

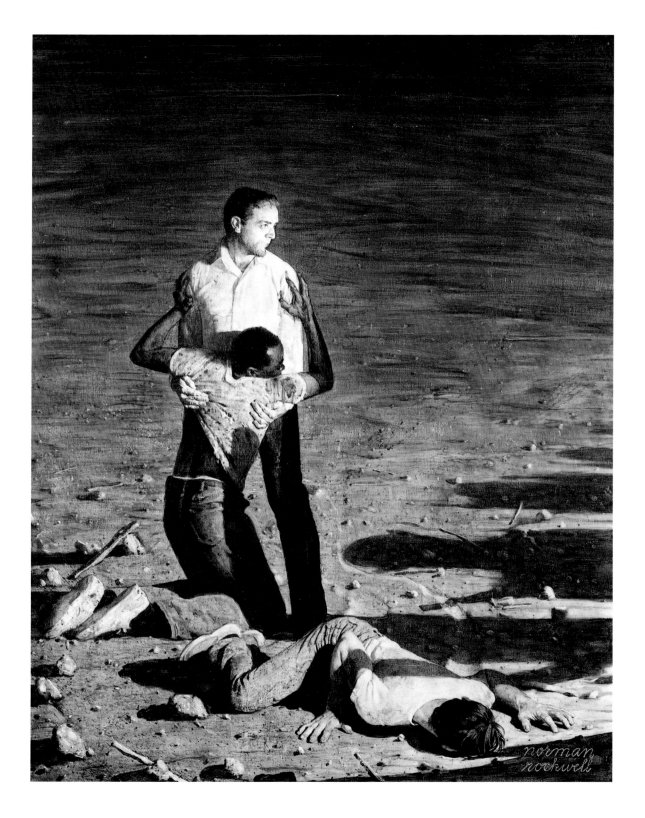

A Happy Adventure, 1972
Ad for McDonald's restaurants
Support and dimensions unknown
Oak Brook, IL, McDonald's Corporation

ILLUSTRATION PAGE 91:
A Time for Greatness, 1964
Illustration for *Look*, July 14, 1964, p. 133
Oil on canvas, 104 x 84 cm
Private collection

Bride to Be, 1973
Cover for Top Value trading stamp catalog
Oil on canvas, 96.5 x 82 cm
Dayton, OH, Top Value Enterprises, Inc.

The colors lack Rockwell's usual sense of richness; the bride and her mother seem almost lost against the background. What does remain, however, is Norman's sweetness and his interest in the dynamics of family life.

efforts to register black voters in the South. Eventually, their bodies were discovered in an earthen dam in rural Philadelphia, Mississippi. Rockwell responded in *Look* in June of 1965 with an imaginative recreation of their martyrdom (p. 89). In the harsh glare of headlights, the shadows of armed Klansmen draw closer to the bleeding figure of Chaney, in the arms of one of his white companions. The painting argues for the brotherhood of the trio and presents their attackers as inhuman creatures of the night. The landscape is an almost Biblical scene of desolation: bare, rock-strewn, and forbidding—a killing ground. It is Norman Rockwell's most passionate indictment to date of the nation whose little missteps and personal follies had been his lifelong preoccupation.

The second great issue of the decade was the spreading conflict in Indochina. By the end of 1965, 150,000 American troops were fighting in Vietnam and opposition to the war was growing. In a work originally painted for the Congress of Racial Equality, Rockwell shows slaughter as the great equalizer of America's blacks and whites. The two young men who lie side by side in death have become *Blood Brothers* (p. 88 bottom). In at least one of the preliminary sketches for the work, they wear the uniforms of U. S. Marines.

Rockwell's role as an observer of American life in the 1960s and early 70s took him abroad, to countries in which the Peace Corps was active. It took him to a research center in Texas, in which he donned a space suit and explored a simulated lunar surface with astronaut Neil Armstrong. His pictorial commentary on events great and small had never been more sought after. But in his final years, before his death in 1978, Norman's acute color sense began to fail him; his hand wobbled; a cloud of confusion made work more and more difficult. Although he went to his studio almost every day, although advertisers and potential portrait subjects flooded the house with requests, Norman Rockwell's America—the place of childhood dreams, and habitual goodness, of happiness, of grave injustice—slipped quietly and gently into history.

Rockwell was mourned by many: Boy Scouts, diehard fans of the *Saturday Evening Post*, a handful of activists, ad agencies. But rarely, until the turn of the new century, by those whose business was art. Perhaps that was because, like all great illustrators, Norman Rockwell's business was pictures. He told stories. Stories that people were interested in. Stories that made them laugh. Terrible stories that made them cringe in shame. For Rockwell, art was a means of telling stories that have become a part of the American memory, the very stuff of the American Dream.

Norman Rockwell 1894–1978
Chronology

1894 Norman Percevel Rockwell is born on February 3 in a brownstone in New York City. He is the second son of Jarvis Waring Rockwell and Nancy Hill Rockwell. He delights in the family's summer vacations in rural New Jersey and upstate New York.

1899 Norman attends the triumphal parade welcoming Admiral Dewey back to the United States. Afterward, he draws battleships, much to the delight of the local boys. Tall and awkward at games, art is Norman's ticket to success.

1903 The family relocates to Mamaroneck, in Westchester County, and eventually takes up residence in a succession of boarding houses.

1908–1909 Norman dislikes high school and has already decided to become a famous illustrator. He makes a long commute into Manhattan to take classes in art at the Chase School.

1909 Rockwell quits high school at age 15 and enrolls in the National Academy School, where he copies plaster casts, as artists of the 19th century had done.

1910 Because one of his idols, illustrator Howard Pyle, was among the founders, Rockwell transfers to the Art Students League. He learns anatomy from

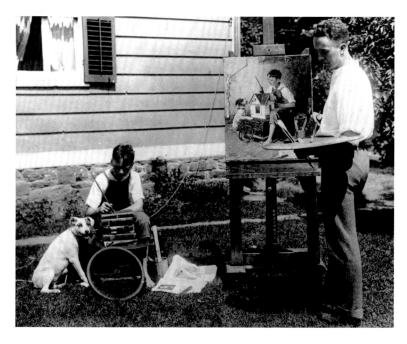

Norman Rockwell painting *Painting the Little House*, 1921

George Bridgman and illustration from Thomas Fogarty.

1911 At 17, Norman illustrates his first book: *Tell-Me-Why Stories about Mother Nature* by C. H. Claudy.

1912 When the Rockwells move back to the city temporarily, Norman rents a studio space on the Upper West Side. His father discovers that the studio is actually a room in a bordello.

1913 Rockwell, with the help of Thomas Fogarty, becomes the art director of *Boys' Life* magazine while still a teenager. He begins to specialize in work for children's magazines.

1915 The Rockwells move to New Rochelle, a thriving enclave for illustrators. With his friend, cartoonist Clyde Forsythe, Norman sets up shop in Frederick Remington's former studio.

1916 Under Forsythe's prodding, Rockwell presents himself at the Philadelphia offices of the *Saturday Evening Post*. The *Post* publishes his first cover—a boy with a baby carriage—on May 20 (p. 9). His career now launched, Norman marries Irene O'Connor, a local schoolteacher.

1918 Rockwell joins the Navy. During his hitch, he is allowed to keep working on lucrative contracts for ads, covers, and illustrations.

1919 Back in New Rochelle, the young Rockwells enjoy the social whirl. He begins a series of prized Christmas covers for the *Post*.

1922 A celebrity in his own right now, Norman is a judge at the Miss America pageant in Atlantic City, along with other well-known illustrators.

1923 During a crisis of confidence, Norman goes to Paris and even enrolls briefly in art school there. He experiments with "modern" art until the editor of the *Post* tells him to get over it. Without his wife, Norman travels somewhat aimlessly to North Africa and South America.

1924 Rockwell's first Boy Scout calendar, published by Brown & Bigelow.

1926 Norman has the honor of painting the first *Saturday Evening Post* cover to be reproduced in full color.

1927 Rockwell goes back to Europe. He joins the country club and parties with F. Scott Fitzgerald. He and Irene have drawn apart.

1929 Separated now, Norman takes up residence at the Hotel des Artistes on Central Park West and suffers another breakdown.

1930 Divorce and a trip to California, where he hobnobs in the movie colony and meets and marries Mary Barstow, another teacher, after a whirlwind romance. They move back to New Rochelle, to a fashionable Colonial Revival house and studio featured in *Good Housekeeping* magazine.

1932 Crippled by another crisis over his art, Norman takes Mary and their newborn son Jerry (Jarvis) to Paris. He does only a handful of *Post* covers all year.

1933 Birth of a second son, Tommy.

1935 Commissioned to illustrate a special edition of *Tom Sawyer* for the Heritage Press (p. 13), Norman goes to Hannibal, Missouri, to see Mark Twain country for himself.

1936 Peter, the last of the Rockwell sons, is born.

Norman and Mary Rockwell model for *The Street Was Never the Same Again*, 1952

1941–1946 To sustain morale on the home front, Rockwell uses a series of eleven *Post* covers to chronicle the adventures of the fictitious Willie Gillis, a raw recruit, from his first days in uniform through his safe return from World War II.

1941 Norman Rockwell's first one-man exhibition opens at the Milwaukee Art Institute. Critical attention to the show is sparse.

1942 Inspired by President Roosevelt's Four Freedoms speech, Norman decides to help the war effort by translating those ideals into pictures.

1943 Stymied by Washington bureaucrats to whom he offers his services, Rockwell paints the Four Freedoms for the *Post* instead. Reprinted in the millions as government posters, the canvases go on a 16-city tour, accompanied by the artist. After the pictures are safely out of Arlington, Norman accidentally burns down his own studio with hot ashes from his pipe. The fire destroys some of his earlier work and his extensive collection of period costumes. The loss helps to turn Rockwell to contemporary themes.

1937 For an illustrated biography of Louisa May Alcott in the *Women's Home Companion*, he does field work in Concord, Massachusetts. With professional models in short supply, he uses travel and the camera to supply the imagery for his work.

1938 Rockwell takes the family to England in a deteriorating political climate.

1939 The family moves to Arlington, Vermont, and establishes close friendships with fellow illustrators and neighbors.

1943–1944 When Ken Stuart takes over as the *Saturday Evening Post's* art editor, he mandates a more literal portrait of America for cover art. Rockwell's work becomes increasingly detailed.

1945 The swank and sophisticated *New Yorker* magazine profiles Norman in a two-part article.

1946 Arthur Guptill publishes his best-selling *Norman Rockwell Illustrator*, the first monograph on the artist. Norman reveals most of his trade secrets in the book, including his reliance on the photograph.

1948 Norman Rockwell is one of the founders of the Famous Artists School of Westport, Connecticut, a correspondence course for aspiring illustrators.

1951 Rockwell paints his most popular *Post* cover, *Saying Grace* (p. 68), for the Thanksgiving issue.

1953 The Rockwells move to Stockbridge, Massachusetts, where Mary is treated at the Austen Riggs Center. Norman begins treatment there, too, for the depression that has plagued him for years.

1957 The Rockwells buy a permanent home in Stockbridge. An article in the *Atlantic Monthly* calls Rockwell politically and artistically irrelevant and accuses him of debasing the taste of the average American. Attacks of this nature continue through the 1960s.

1959 Mary Rockwell dies suddenly of a heart attack.

1960 The *Saturday Evening Post* serializes Rockwell's memoirs, also published in book form that year: *My Adventures as an Illustrator* is a bestseller.

1961 Norman Rockwell marries for a third time and attends painting classes in Stockbridge.

1962 Intrigued by the "drip" paintings of Jackson Pollock, Norman paints one himself for use in a *Post* cover (p. 81).

1963 Rockwell leaves the *Saturday Evening Post* after 47 years. His last *Post* cover appears on December 14.

1964 Rockwell goes to work for *Look* magazine with pointed studies of current events and social issues. *The Problem We All Live With* (pp. 82–83) inaugurates the series.

1968 The Danenberg Galleries in New York holds a Rockwell retrospective of 40 canvases; *Saying Grace* (p. 68) is hung in the front window.

1969 Rockwell, his wife, and some local supporters open The Old Corner House in Stockbridge, where his paintings are displayed.

1972 Danenberg celebrates his 60 years in art with another exhibition. It is panned by influential critic John Canaday in the pages of the *New York Times*.

1976 Rockwell's last cover appears on *American Artist* magazine.

1977 President Gerald R. Ford awards Norman Rockwell the Presidential Medal of Freedom.

1978 At the age of 84, Norman Rockwell dies in Stockbridge on November 8.

1993 The Norman Rockwell Museum at Stockbridge opens in a building designed by architect Robert A. M. Stern to spotlight the Four Freedoms.

1997 The Smithsonian's National Museum of American Art (Washington, DC) collaborates with Harry N. Abrams in publishing the first modern reexamination of Rockwell's work.

1999 A major touring exhibition of Rockwell's work begins a four-year tour under the joint auspices of the High Museum of Art (Atlanta, GA) and the Norman Rockwell Museum at Stockbridge, Massachusetts. A serious consideration of the style and iconography of his work, the show is credited with softening the attitude of many formerly hostile critics.

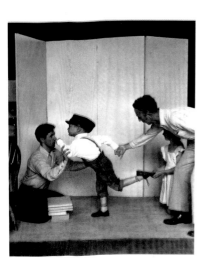

ILLUSTRATION LEFT:
Norman Rockwell and his assistant Don Winslow posing model for *The Street Was Never the Same Again*, 1952

ILLUSTRATION RIGHT:
Norman, Jarvis and Thomas Rockwell posing for *Casey at the Bat* (unpublished), c. 1950

Bibliography

Bogart, Michele H.: *Artists, Advertising, and the Borders of Art*. Chicago, 1995.

Buechner, Thomas S.: *Norman Rockwell, Artist and Illustrator*. New York, 1970.

Buechner, Thomas S.: *Norman Rockwell, A Sixty Year Retrospective*. New York, 1972.

Claridge, Laura: *Norman Rockwell, A Life*. New York, 2001.

Cohn, Jan: *Creating America, George Horace Lorimer and the Saturday Evening Post*. Pittsburgh, 1989.

Cohn, Jan: *Covers of the Saturday Evening Post*. New York, 1995.

Coles, Robert: *The Story of Ruby Bridges*. New York, 1995.

Ermoyan, Arpi: *Famous American Illustrators*. Edison, 2002.

Finch, Christopher: *Norman Rockwell, 332 Magazine Covers*. New York, 1979.

Finch, Christopher: *Norman Rockwell's America*. New York, 1985.

Flythe, Starkey, Jr.: *Norman Rockwell and the Saturday Evening Post*. Vol. 1. New York, 1994.

Gregory, G.H.: *Posters of World War II*. New York, 1993.

Guptill, Arthur L.: *Norman Rockwell Illustrator*. New York, 1946.

Marling, Karal Ann: *Norman Rockwell*. New York, 1997.

Mendoza, George: *Norman Rockwell's Patriotic Times*. New York, 1985.

Meyer, Susan E.: *America's Great Illustrators*. New York, 1978.

Meyer, Susan E.: *Norman Rockwell's People*. New York, 1981.

Meyer, Susan E.: *Norman Rockwell's World War II*. San Antonio, 1991.

Moffat, Laurie Norton: *Norman Rockwell, A Definitive Catalogue*. 2 vols. Stockbridge, 1986.

Murray, Stuart and James McCabe: *Norman Rockwell's Four Freedoms*. Stockbridge, 1993.

Norman Rockwell, A Centennial Celebration. New York, 1993.

Norman Rockwell, Pictures for the American People. New York, 1999.

Reed, Walt: *Great American Illustrators*. New York, 1979.

Rockwell, Norman, as told to Tom Rockwell: *My Adventures as an Illustrator*. New York, 1994.

Sommer, Robin Langley: *Norman Rockwell, A Classic Treasury*. Greenwich, 1993.

Stolz, Donald R. and Marshall L. Stolz: *The Advertising World of Norman Rockwell*. New York, 1985

Stolz, Donald R. and Marshall L. Stolz: *Norman Rockwell and the Saturday Evening Post*. Vols. 2 and 3. New York, 1994.

The Norman Rockwell Album. Garden City, 1961.

Walton, Donald: *A Rockwell Portrait, An Intimate Biography*. Kansas City, 1978.

Photo Credits

The publisher wishes to thank The Norman Rockwell Family and the archives, museums, private collections, galleries and photographers who kindly supported us in the making of this book and provided photographs of works. Where not otherwise indicated, the reproductions were based on material in the publisher's archive. In addition to the institutions and collections named in the picture captions, special mention should be made of the following:

American Illustrators Gallery, NYC/
www.asapworldwide.com: pp. 11, 12, 18, 21, 33
Art from the Archives of Brown & Bigelow, Inc.:
pp. 70, 71
Brooklyn Museum of Art: p. 41

Collection of The Norman Rockwell Museum at Stockbridge, MA: pp. 1, 15, 20, 28, 34–35, 47, 48, 49 b. l., 57, 62, 74, 82–83, 89, cover
Courtesy of the National Museum of the U.S. Army Art Collection: p. 32
Courtesy of the Berkshire Museum: p. 66
Mark Twain Home Foundation, with the permission of Heritage Press: p. 13
McDonald's Corporation: p. 90 t.
Norman Rockwell Art Collection Trust, The Norman Rockwell Museum at Stockbridge, MA: pp. 6, 9, 30, 36, 37, 39, 49 t., b. r., b. m., 59, 73, 75, 78, 79, 85, 86–87, 88
Photo by Gene Pelham: pp. 2, 43, 93–95, back cover
Photo by Louie Lamone: p. 80

Photo courtesy of the Norman Rockwell Museum at Stockbridge: pp. 2, 7, 8, 14, 17, 19, 29, 31, 40, 42, 43, 45, 46, 53, 60, 61, 63, 64 l., 65, 67, 68, 69, 72, 76, 77, 80, 92–95, back cover
Photo courtesy of the Martin Diamond Fine Art Archives: pp. 55, 91
The Curtis Publishing Company: pp. 16, 22–23, 26–27, 51, 58, 64 r., 81